POSTCARD HISTORY SERIES

The Iowa State Fair
IN VINTAGE POSTCARDS

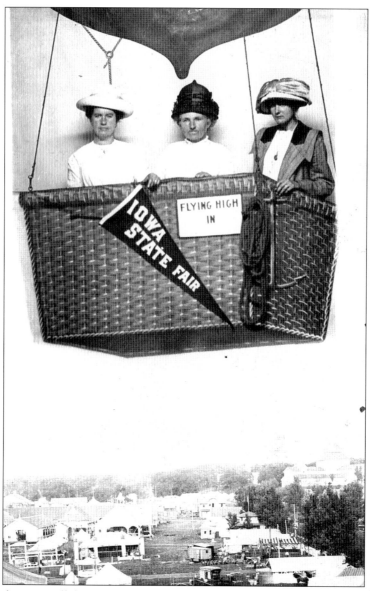

Eye-catching hats were all the range when this photograph was taken, around 1908. Three women proudly model their hats as they fly high over the fair in a hot air balloon, thanks to trick photography. Balloons and automobiles were two of the more popular props that early photographers used to sell souvenir postcards to fairgoers. The view under the balloon is the manufaturers' exhibits and concessions area east of the Grandstand, where the midway is located today.

On the front cover: a couple pauses to enjoy the view looking northwest from Exposition Hill. They had an excellent vantage point to watch the new roller coaster, built for the 1915 fair. (Author's collection.)

On the back cover: Curt Teich Company of Chicago published this 1947 "large letter" souvenir postcard. From 1933 to 1956, they published over 1,000 similar postcards with the large letters spelling out the name of the city, state, or tourist attraction. (Author's collection.)

POSTCARD HISTORY SERIES

The Iowa State Fair
IN VINTAGE POSTCARDS

Ron Playle

ARCADIA

Published by Arcadia Publishing
Charleston SC, Chicago IL, Portsmouth NH, San Francisco CA

Printed in the United States of America

Library of Congress Catalog Card Number: 2005938283

For all general information contact Arcadia Publishing at:
Telephone 843-853-2070
Fax 843-853-0044
E-mail sales@arcadiapublishing.com
For customer service and orders:
Toll-Free 1-888-313-2665

Visit us on the Internet at http://www.arcadiapublishing.com

CONTENTS

ACKNOWLEDGMENTS

Creating this book took many resources and contributions by others. My sincere thanks to each of the following people who have helped me to share my interest in the Iowa State Fair and my collection of postcards. Foremost was my son, David, an avid fairgoer. He spent countless hours alongside me researching state fair records and newspaper microfilm. Sharon Avery, Ellen Huston, and the library staff at the State Historical Society of Iowa found sources for information that I otherwise would not have found. Bill Campfield, superintendent of the Iowa State Fair Museum, shared his knowledge of the fair and allowed me to pore over the museum's collections. Thanks especially to my wife, Linda, who encouraged me to write this book, and supported me all the way. She also reviewed the text and contributed ideas that made this a better book.

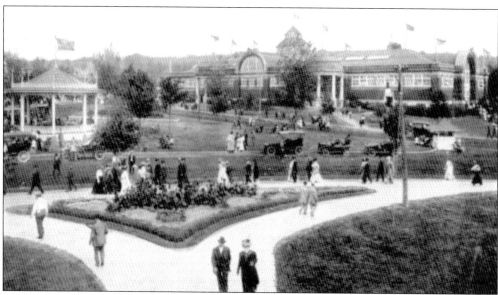

Fashionably dressed fairgoers stroll around the fairgrounds, c. 1912. This view, looking east from the Administration Building, shows the Band Stand and Agriculture Building. The Band Stand was in the area known today as the Triangle.

INTRODUCTION

Iowa's first state fair was held Wednesday, October 25, through Friday, October 27, 1854, in Fairfield. The fairgrounds were on six acres surrounded by a high rail fence. The entry fee was 25¢, and attendance estimates varied from 7,000 to 10,000. The big event was the female equestrianship contest where women competed in horseback riding on a 1,500-foot-long oval track. Originally scheduled for one day, the event was so popular that it was repeated a second day.

The second fair, in 1855, was again at Fairfield. In subsequent years it went on the move so Iowans from around the state could have an opportunity to attend. The fair was held in the following cities: Muscatine, 1856–1857; Oskaloosa, 1858–1859; Iowa City, 1860–1861; Dubuque, 1862–1863; Burlington, 1864–1866; Clinton, 1867–1868; Keokuk, 1869–1870, and again in 1874–1875; Cedar Rapids, 1871–1873 and again in 1876–1878.

In 1879, the fair moved to Brown's Park on the west side of Des Moines. It consisted of 60 acres located between Thirty-eighth Street on the east and Forty-second Street on the west, and Center Street on the north and Grand Avenue on the south. The Fair had an eight-day run, and attendance was more than 100,000. In 1884, the legislature appropriated $50,000 to purchase a permanent location for the fair, on condition that the City of Des Moines would contribute an equal sum for improvements to the site.

In 1885, the Calvin Thornton farm on the east side of Des Moines was purchased for the permanent location of the fair. The site covered 266 acres between University and Dean Avenues, and East Thirtieth to East Thirty-sixth Streets. The fair took possession in June 1886, and by the time of the dedication on September 7, 1886, about 60 buildings had been erected, along with a half-mile racetrack and 50 wells. Four existing Thornton buildings were left on the fairgrounds. Part of one of the original Thornton buildings, the basement of Grandfather's Barn, still exists today. It is a classic example of early Iowa agricultural architecture.

The first cards of the Iowa State Fair were advertising "trade" cards from the late 1800s. They were not mailable, nor did they show any views of the fair. They were "stock" cards that local printers used to print a variety of advertisements. They were brightly colored litho cards of various sizes, usually with illustrations of children or general scenic views. Many of them ended up being pasted into scrapbooks. Some of the fair trade cards are shown at the beginning of this book.

The popularity of trade cards peaked around 1890, and by the early 1900s, they had all but disappeared. The first picture postcards in the United States were views of the 1893 World's Columbian Exposition in Chicago, printed on 1¢ government postal cards. In May 1898, an act of Congress granted permission to nongovernment printers to publish and sell "private mailing cards" that could be mailed at the same 1¢ rate as the government postal cards. In December 1901, permission was granted to use the words "post card" on backs of privately printed cards.

The backs could only be used for the address—the messages had to be written on the front "picture" side. In March 1907, laws were changed to allow "divided backs" on postcards for both address and message.

The earliest Iowa State Fair postcards in my collection, which I believe to be the first published, are from 1904. That was also the year the first postal substation was established at the fair. A 1909 newspaper story reported that 25,000 souvenir postcards were sent through the fair's postal substation from Monday through Friday, twice as many as any previous year. "The sellers on the grounds made good money with pictures of Des Moines and the state fair, which the rural residents delight in sending to the folks at home."

From an average of 5,000 mailed per day in 1909, the average increased tenfold by 1911. During one day in 1911, C. D. Wagner, supervisor in charge of the fair post office, said that 50,000 postcards were mailed all over the United States by Iowa State Fair visitors. He estimated that nine-tenths of the postcards were pictures of Iowa State Fair scenes, and during the week, 250,000 people would receive postcards from the fair.

By 1915, the postcard craze was over. Most of the postcards in the early 1900s were printed in Germany and exported to the United States. World War I brought an end to this practice. Publishers in the Unites States started printing their own postcards, but the quality was not as good. The "white border" postcard era, during which the cards are distinguished by a white border around the image, was from 1915 to 1930. The "linen" postcard era, during which the cards were printed on linen-like paper with a high rag content, was from 1930 to the early 1950s. "Chrome" postcards, published from 1939 until today, have cards that are printed in full color on card stock with a shiny surface.

Some of the best postcards of the Fair are "real-photo" postcards—photographs that were developed onto photographic paper with postcard backs. They offer greater details than a printed postcard. Local photographers, and even the average person, could easily make them by using cameras such as the Kodak 3-A. Carried a step further, the Kodak "autographic" camera had a feature where you could write a caption or picture number that would appear on the negative. Real-photo postcards of the fair date from the early 1900s to the 1950s.

The postcards illustrated in this book range from 1904 to the 1950s. All but two of them are from the my personal collection. After 1915, there were fewer and fewer postcards published of the fair. For the most part, the last postcards of the fair were published in the 1950s. With the exception of a few modern advertising postcards, or reproductions of early Iowa State Fair views, there are none being published today. Instead, fairgoers use cell phones and other wireless devices to relate their latest experiences at the fair.

One

GLIMPSES OF
FAIRS GONE BY

Before there were picture postcards, there were advertising trade cards, like this one from 1890. Railroads were practically the only way to reach the Iowa State Fair. On one busy day, the Rock Island Railroad carried over 50,000 passengers. Fairgoers could watch a Roman chariot race, trotting stakes, or bicycle races. Farmers saw a butter extractor, a recently patented contraption operated by a steam engine. It could make 60 pounds of butter per hour from fresh sweet milk. Sideshows were allowed, but "no gambling or indecent institutions are allowed." The *Iowa State Register* on September 4, 1890, proclaimed "Among the 50,000 people on the grounds of the Fair yesterday, there was not, as far as anyone knows, a drunken man to be found."

Iowa State Fair, Des Moines,
Aug. 28—Sept. 4, 1891.

The Finest Scenery and Most Delightful Fair
Ground in the Country.

An 1891 trade card advertised the fair, where a dozen new buildings were erected, and enlargements were made to the dairy and agriculture halls. Some 600 electric lights were put on the grounds, and "the lights stretched away in sinuous rows in a scene of nocturnal splendor." About 50 electric lights were placed around the racetrack, and the first night races were held under electric lights. G. W. Moore and his dog made parachute leaps. They went up several hundred feet sitting in a large ring suspended below a balloon, then man and dog dropped using separate parachutes. Carrie Lane Chapman Catt delivered an address on women's suffrage. The back of the card advertised a "Delightful Grove for camping, water in abundance. Quick transit from city to grounds by double track railway and electric car lines."

IOWA STATE FAIR,
DES MOINES,
SEPTEMBER ———
1, 2, 3, 4, 5, 6, 7 and 8, '93.

TUESDAY Is Children's Day, and I am on my way.

J. W. McMullin, Prest. John R. Shaffer, Sec'y.
OSKALOOSA. DES MOINES.

This 1893 trade card advertised Tuesday as Children's Day. Due to the competition of the World's Fair in Chicago, there had been doubts whether or not the Iowa State Fair should be held in 1893. The decision was made to go ahead, and it turned out to be a financial failure. Many fairgoers and exhibitors went to the World's Fair instead. Receipts were down by more than one half, and the fair ended the year $25,000 in debt. Fair secretary John R. Shaffer thought the World's Fair was partially the reason, but thought the depression was the strongest reason.

In 1899, this trade card advertised the "Century Closing Exposition." W. F. "Doc" Carver Amusements performed at the Grandstand, which included horses, elk, and a bicyclist, all of whom dove from a 40 foot platform. Historical exhibits showed development from the pioneer era through 1899. Gen. Charles King lectured on the Philippines insurrection, and evangelist Francis Murphy lectured on temperance. Fairgoers quenched their thirst at "hop ale" stands.

The Great Iowa
State Fair
and
Century Closing Exposition

DIVING HORSES
ROPING
ROUGH RIDING

Good Music and Fun for all.

Aug. 25 to Sept. 2, 1899

Gate keeper will admit girl or boy under *12* years FREE. Aug. *29* only. (This will not admit you any other day or date.)

IOWA STATE FAIR,
August 23-31, 1901.

Come and see the State Capitol and visit the Fair. The boy or girl under 15 who receives this card will be admitted FREE Monday, August 26th, both day and evening. (Not good any other day.) Greatly increased Premiums. Best of exhibits in all lines. Grand Attractions, day and night. Splendid Fire Works. Speed Program, Catalogue and Bulletins FREE.

R. J. JOHNSTON, Prest., Humboldt, J. C. FRASIER, Vice-Prest., Bloomfield,
G. D ELLYSON, Treas., Des Moines, G. H. VAN HOUTEN, Secy., Des Moines.

CALVERT LITH. CO., DETROIT

In 1901, this card admitted children free on Monday. Entertainment included the Hull and Rose Minstrel Show, aerialists The Flying Banvards, and Vallecita the woman lion tamer. One of the improvements on the grounds was the "free automatic and odorless Sanitary Closets." Fireworks included a "portrait in fire" of A. B. Cummins, the Republican candidate for governor. Shannon and Mott Milling of Des Moines gave away 100,000 tiny sacks of Falcon Flour.

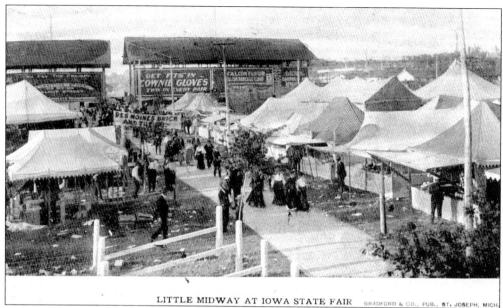

LITTLE MIDWAY AT IOWA STATE FAIR BRADFORD & CO., PUB., ST. JOSEPH, MICH.

The two *c.* 1904 private mailing cards on this page are the oldest postcards in Ron Playle's collection (the author), and believed to be the first published of the fair. Signs visible in this midway view include Des Moines Brick and Tile, Cownie Gloves, and Falcon Flour. It was reported that "cheap, trashy sideshows" were being excluded this year, and only a few allowed that were "known to be absolutely worthy."

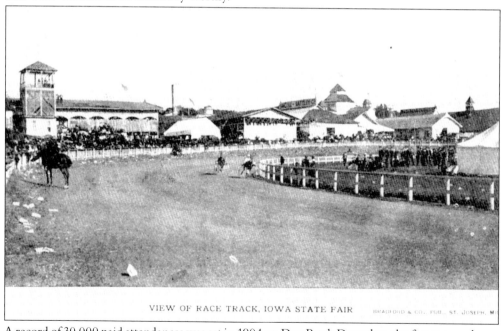

VIEW OF RACE TRACK, IOWA STATE FAIR BRADFORD & CO., PUB., ST. JOSEPH, M

A record of 30,000 paid attendances was set in 1904 on Dan Patch Day when the famous racehorse appeared on the racetrack. A young woman was arrested when she was found sitting on the lap of a young man at the fair entrance. Municipal court judge A. J. Mathis released her, saying, "Spooning may jar on some people's nerves, but it is no crime." Police raided three beer sellers at the fair, including one caught selling beer in pop bottles.

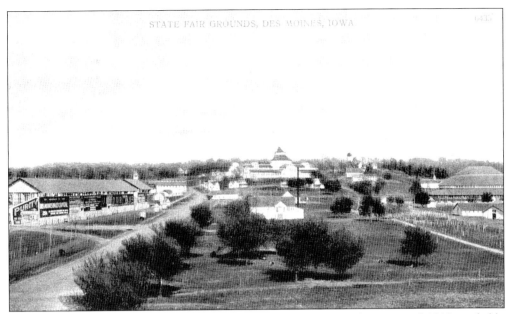

This postcard was published around 1908, but the photograph is from around 1903, probably the earliest view of the fair published on a postcard. It looks east along Grand Avenue, with the Grandstand on the left side and the Exposition Building in the center background. It shows the fairgrounds after the Livestock Pavilion on the right side was built in 1902, but before the Agriculture Building was built in 1904.

A 1905 postcard combined four views on one card. There were races between fire company wagon horses, including world champions Jack and Jack, the famous east Des Moines fire team. The firemen got some real work on August 29, when two fair buildings burned—the Dodd and Struther Electrical Exhibit Hall, and the Valley Junction M. E. Church Dining Hall. For awhile, the entire dining hall row was in danger.

13

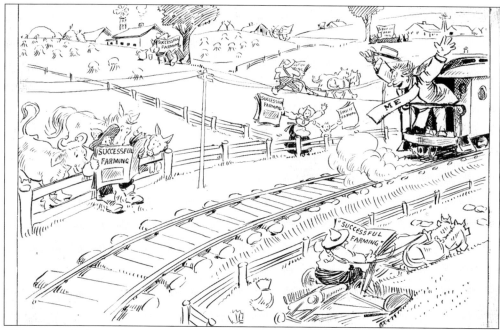

This postcard, drawn by Jay N. "Ding" Darling, was given to early fairgoers at the *Successful Farming* magazine exhibit. Printed on the back: "Fair Grounds, Des Moines. Just arrived. Passed through the most 'Successful Farming' district you ever saw. Yours Truly." Darling was an editorial cartoonist for the *Des Moines Register* from 1906 through 1949. In 1911, Pain's Pyrotechnics show reproduced in fireworks Darling's State Fair cartoon "The Annual Reunion of the Iowa Family."

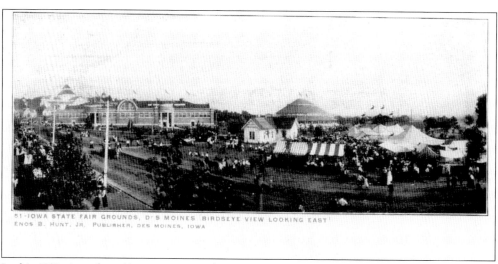

In this 1905 view, the midway was across the street, south of the Grandstand. In 1910, the midway moved to where it is today, just east of the Grandstand. Fair management forbade the Parker Amusement Company, the midway concessionaire in 1910, to have shows with "scantily clad girls." In addition, two Parker representatives were fined $50 each in police court for exhibiting moving pictures of the Jeffries-Johnson prizefight.

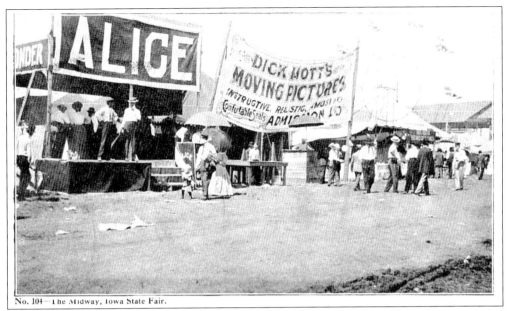

No. 104—The Midway, Iowa State Fair.

Herbert A. Kline ran the midway concessions in 1908, which included Alice the Wonder, said to be a "wonderfully hairy little woman," and Dick Mott's Moving Pictures. Other Kline concessions were a trained animal circus, Randion the Living Torso, Bachman Glass Blowers, the London Ghost Show, an Oriental show, Serpentina, Dickey's Circle D Wild West Show, a flea circus, and a Philippine village with 14 Igorots in native costumes.

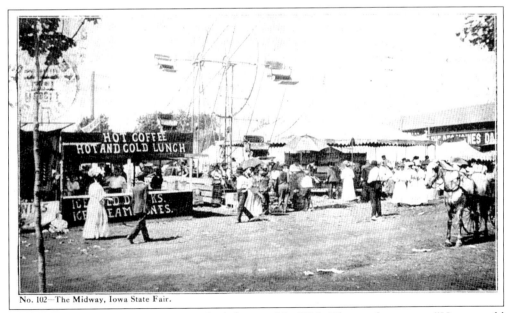

No. 102—The Midway, Iowa State Fair.

This view of the midway is postmarked August 23, 1908. The sender wrote, "How would you like to ride over this Ferris Wheel? Yesterday was Children's Day and a great many were patronizing it whenever I happened to pass where it is located. The grounds are well filled with attractions, a place to spend 5 or 10 cents with but little return. With love, Pa Pa."

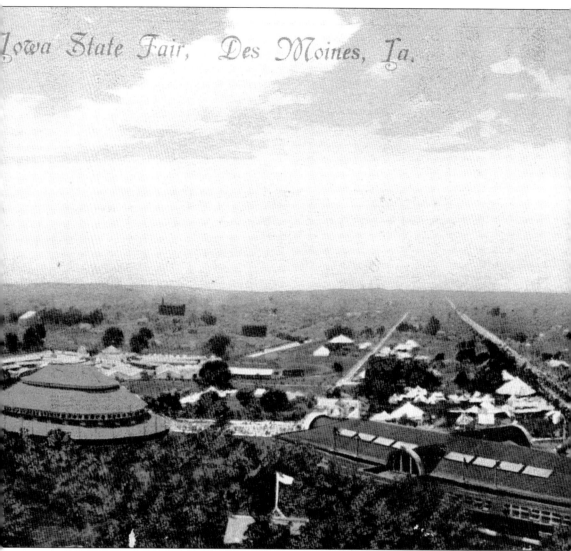

Iowa State Fair, Des Moines, Ia.

This 1906 view is looking west, and was probably taken from the top of the Exposition Building, high on Exposition Hill. General admission at the gates was 50¢. After 5:00 p.m., admission was only 25¢. Grandstand admissions were 15¢ and 25¢. Reserved seats cost 50¢. Soldiers of the War of Rebellion (Civil War) and Mexican war were admitted free on Soldier's Day, as were their wives or widows. A soldier's reunion and campfire was held in the assembly tent at

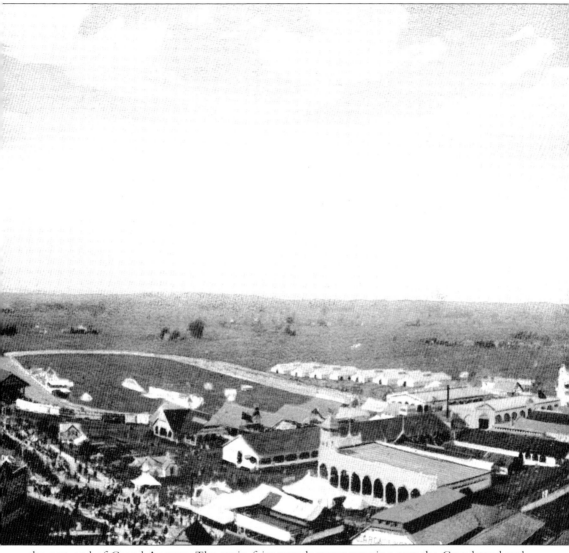

the east end of Grand Avenue. The main fairgrounds street running past the Grandstand and stretching off into the distance in this view is Grand Avenue. When the fairgrounds were laid out in 1886, the city also laid out Grand Avenue. Seven miles long, it was said at the time to be the "longest boulevard in the state."

Fruit raised in the famous Koshkonong District.

FROM

Iowa State Fair Grounds,

1907

OREGON COUNTY MO.

Shown here are two complimentary cards from the 1907 Iowa State Fair advertising fruit from the Koshkonong District, Oregon County, Missouri. In 1907, the railroads offered a flat rate of 2¢ per mile from anywhere in Iowa to the fairgrounds. Defender, the sweepstakes champion steer owned by Iowa State College, said to be "the most perfect steer ever produced," was shown at the fair.

Fruit raised in the famous Koshkonong District.

FROM

Iowa State Fair Grounds,

1907

OREGON COUNTY, MO.

In 1907, King Edward's royal horses were at the national stock show. *Vesuvius*, the spectacular night show by Pain's Pyrotechnics, performed every night at the Grandstand, with concerts, vaudeville, and fireworks. It was advertised as the "greatest fireworks scene ever seen in America." Vaudeville acts included the Four Sensational Boises, the Arab Fezzan Troupe, La Toy Brothers clown acrobats, Millie Turnour, Wills and Hassan Equilibrists, and the Jackson family of cyclists.

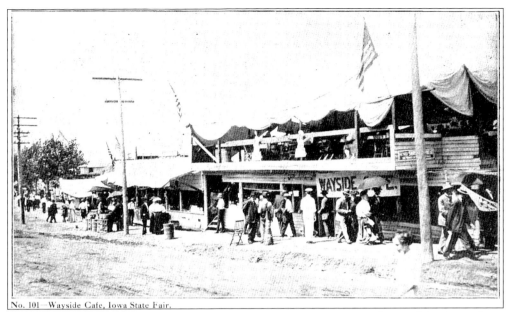

No. 101—Wayside Cafe, Iowa State Fair.

The Wayside Cafe, managed by Mr. and Mrs. L. F. McCray, was northeast of the Agriculture Building. In 1908, they advertised "First Class Lunch hot or cold, drinks, fruits, Ice Cream and Confectionery." The year 1908 was also the year the fair ran out of concession space. Superintendent W. C. Brown, the man in charge of such things, arranged for an enterprising exhibitor to use a tree! No mention was made of what the concession was.

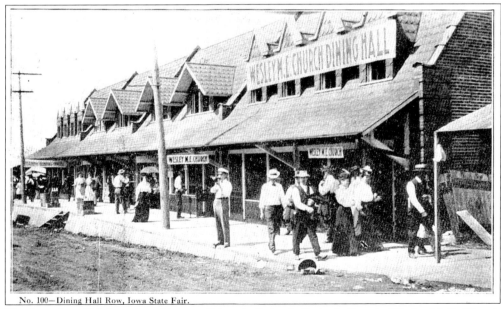

No. 100—Dining Hall Row, Iowa State Fair.

The Iowa State Fair has a long history of church dining halls, including the Wesley M. E. Church Hall, shown here. The last one, the Chesterfield Christian Church Hall, was torn down in 2003. A common complaint in the early days was the "fearful din" at mealtime when the dining halls would ring their farm bells. An 1890 newspaper called them "instruments of torture" and said the bell-ringers "ought to be bounced from the grounds as nuisances."

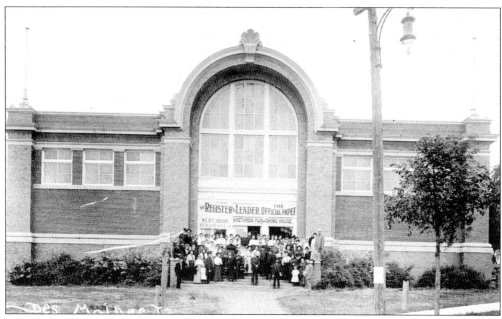

The "Dunkers" (German Baptist Brethren) Conference was held at the fairgrounds June 3 through June 10, 1908. Opening session was on June 3. June 6 was Social Saturday, then Spiritual Sunday, and Missionary Monday. The business meetings were on Tuesday and Wednesday, June 9 and 10. This photograph was taken at the south end of the Agriculture Building. Signs over the entrance read, "The Register & Leader—the Official Paper" and "Brethren Publishing House."

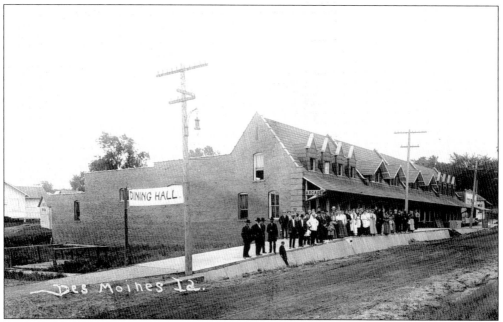

The dining halls along Grand Avenue were used during the Dunkers Conference. Food consumed cost at least $10,000, including $1,100 for meat, $960 for bread, $1,000 each for butter and eggs, and $487 for ice cream. This did not include "the dinners bought downtown." Family reunions were held at the conference, the largest of which was the Goughnour family.

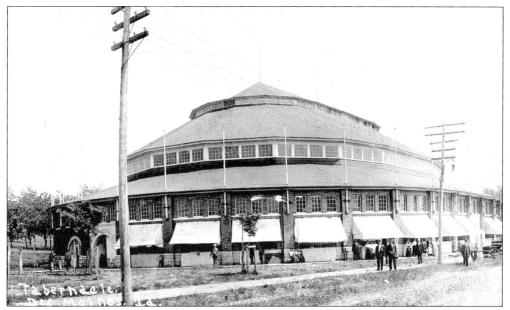

This view of the Livestock Pavilion is captioned "Tabernacle," because the Dunkers used it to worship at their conference. They also held their business meetings there. A petition brought to the meeting to allow women to wear jewelry and "frills of dress" was shelved. Items that passed included a name change from German Baptist Brethren to Church of the Brethren, and the barring of patent medicine advertisements from church papers.

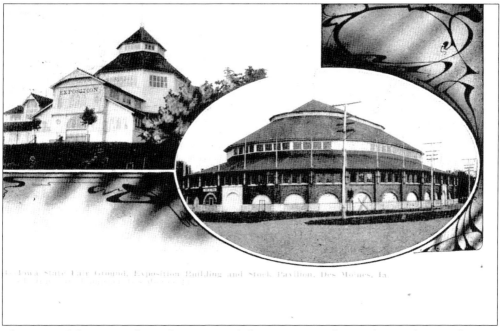

This view of the Livestock Pavilion was mailed June 8, 1908, during the Dunkers conference. Evidently the alcoves under the pavilion were used by some of the attendees, perhaps as sleeping quarters. The sender of this card wrote "Here is the building where Services are held. We have the room marked X on the front. I met Sister Higgs right at our room last night."

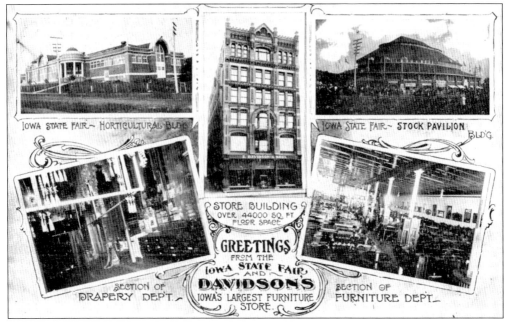

Davidson's Furniture Store, advertised as "Iowa's Largest Furniture Store," had big elaborate exhibits at the fair. Shown here are complimentary postcards published for fair visitors. A 1908 newspaper story mentioned that "Souvenir Postal Cards distributed by Davidson's to visitors have reproductions of the magnitude of some of the elaborate displays besides showing some interesting scenes of the Fair."

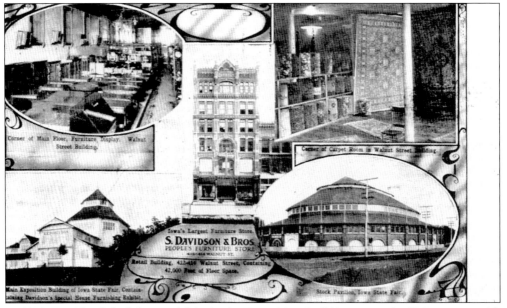

In 1908, Davidson's had three exhibits in the Exposition Building: an entire living room with massive mahogany pieces that "seemed to have been transported from the home of a wealthy Virginian," a dining room in the Louis XVI style furnished in Circassian Walnut (valued at $1,000, and said to be the costliest set of furniture ever brought to Des Moines), and a room filled with rare oriental rugs and fine carpets.

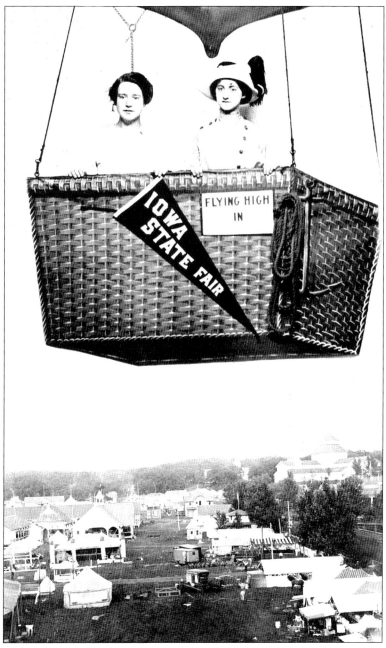

Hot air balloon ascensions were one of the favorite attractions at early fairs. Through the magic of trick photography, fairgoers could have their photograph taken in a balloon high over the fair as these women did around 1908. The photograph beneath the balloon affords a nice view of the manufacturers' exhibits, and the concession area just east of the Grandstand, where the midway is today. One of the small tents held a flea circus. One of the attractions in 1908 was a 35 foot brilliantly colored python from South America. Herbert Kline, the concessionaire, wanted to show it behind plate glass, or in a tree behind an iron bar mesh fence. But fair vice president W. C. Brown said the snake had to remain in his box and "not have a chance to arch his back and coil sinuously for the edification of morbid minded people!"

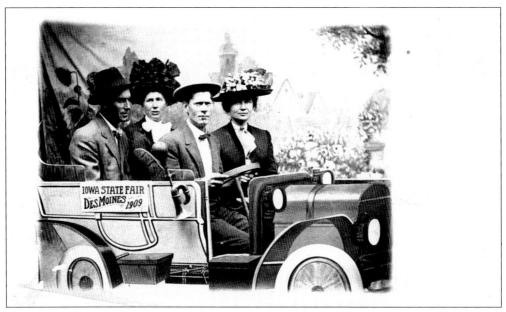

Another favorite prop of fair photographers in the early 1900s was a fake automobile. If one could not afford a real automobile, they could at least impress their friends by having their photograph taken in a simulated one. The couples in this 1909 souvenir-photo postcard were well dressed, as were most fairgoers during this era. The fashionable women of 1909 wore large, elaborately decorated hats, and the men wore jackets and bow ties.

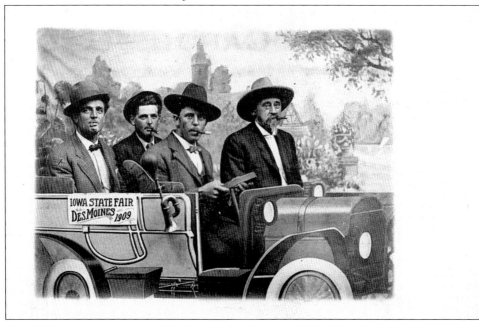

Four well-dressed men in 1909 smoked cigars as they had their photograph taken in a fake automobile. The Iowa State Fair in 1909 was held from August 27 to September 3. Fairgoers could choose from "twelve concerts every day, two big night shows, or high class racing." The Stock Pavilion had an "Amazing Hippodrome Show, Concert, and Special Vaudeville Show" to go along with livestock judging. There were over 600 livestock exhibitors that year.

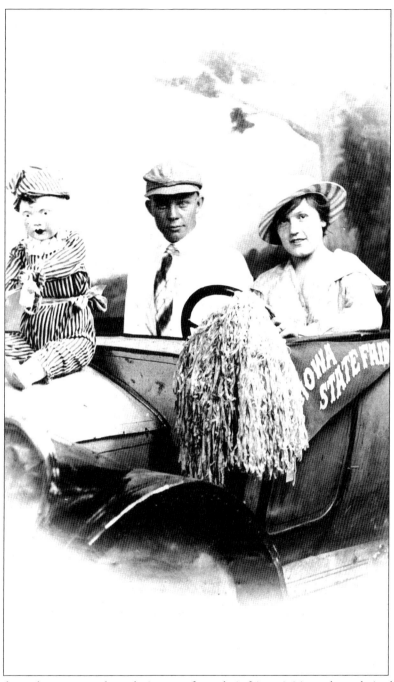

This well-dressed young couple took time out from their fair activities to have their photograph taken in a fake automobile. Sitting magnificently on the hood of the auto is a large doll in striped coveralls. It very well might have been a prize won by the young man to impress his girlfriend, and probably cost him more to win than the prize was worth. Midway games in the early 1900s included smashing a big hammer to ring a bell, throwing darts to break balloons, shooting galleries, and throwing balls to knock over bottles. And of course, the games promised, as they do today, "a winner every time!"

This photograph was taken in 1909, looking west from the south end of the Agriculture Building. The Administration Building is in the background between the trees. People picnicking under the trees are enjoying the afternoon. Fairgoers of this era were fashionably dressed. The women wore long dresses, men wore suits, and many were wearing a hat. It does not look like it would have been very comfortable on hot fair days.

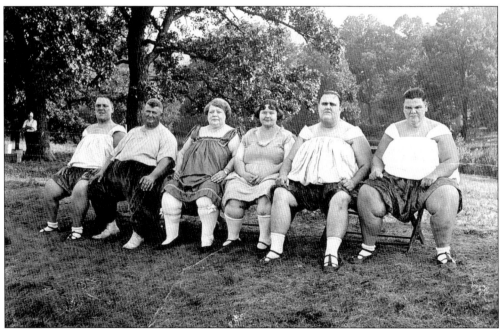

Midway sideshows of the early 1900s, before shows of this nature were deemed politically incorrect, included "fat people." Handwriting on the back of this postcard identifies these six people as the "Karn Family—a group in show business at the Iowa State Fair in 1910." Their names and weight were listed: father 612, mother 565, sister 385, Jack 444, Jill 461, and James 481.

Iowa State Fair Souvenir
August 24 - September 1, 1911

MOLA MOLA
or GIANT SUNFISH

Caught about ten miles at sea, from Long Beach, California, by D. H. Buxton, of the Globe Machinery & Supply Co., of Des Moines, Iowa.

Dimensions and weight of fish when taken from the water :
> Length, 10 feet, 1 inch
> Tip to Tip of Fins, 10 feet, 9¾ inches
> Thickness, 2 feet, 6 inches
> Weight, approximately 2700 pounds

The *Rhinoptera Steindachneri*, or Stingaree, was caught by Buxton from the wharf in San Pedro harbor.

The Albicore was caught by Marie Buxton, with rod and reel.

Two 1911 fair souvenir cards, showing Mola Mola Giant Sunfish caught by D. H. Buxton of Globe Machinery and Supply Company, were on display at the Globe exhibit. In another 1911 advertising promotion, the Associated Manufacturers of Waterloo had the "mysterious" Chore Boy Man (F. J. Martin from Waterloo) wandering the fairgrounds. Anyone who identified and "caught him" won a free $35 Chore Boy Engine. In 1911, the Wright Brothers biplanes appeared at the fair, flown by Philip Parmalee and Clifford Turpin. After each landing, so many kids would stampede toward the planes that police "had to use strenuous language and wave clubs threateningly to keep the youngsters from mauling the fragile planes to tatters." Like many early aviators, Parmalee died young. He was only 25 when his plane crashed during a 1912 exhibition in Yakima, Washington.

Iowa State Fair Souvenir
August 24 - September 1, 1911

MOLA MOLA
or GIANT SUNFISH

Caught about ten miles at sea, from Long Beach, California, by D. H. Buxton, of the Globe Machinery & Supply Co., of Des Moines, Iowa.

Dimensions and weight of fish when taken from the water :
> Length, 10 feet, 1 inch
> Tip to Tip of Fins, 10 feet, 9¾ inches
> Thickness, 2 feet, 6 inches
> Weight, approximately 2700 pounds

The *Rhinoptera Steindachneri*, or Stingaree, was caught by Buxton from the wharf in San Pedro harbor.

The Albicore was caught by Marie Buxton, with rod and reel.

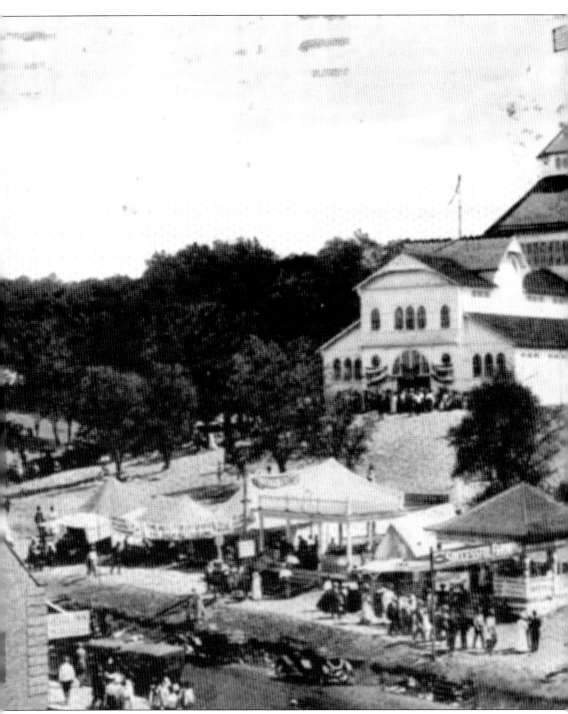

The Exposition Building overlooked publishers' tents along Grand Avenue. On the right side (across the street from today's beer tent) was the WCTU (Women's Christian Temperance Union), which advocates abstinence from alcohol. In the lower right corner is part of the Iowa Women's Suffrage Association cottage. In 1909, Iowa State Fair officials would not let the suffragettes sell balloons and pennants on the grounds, so they stood outside the gates and sold

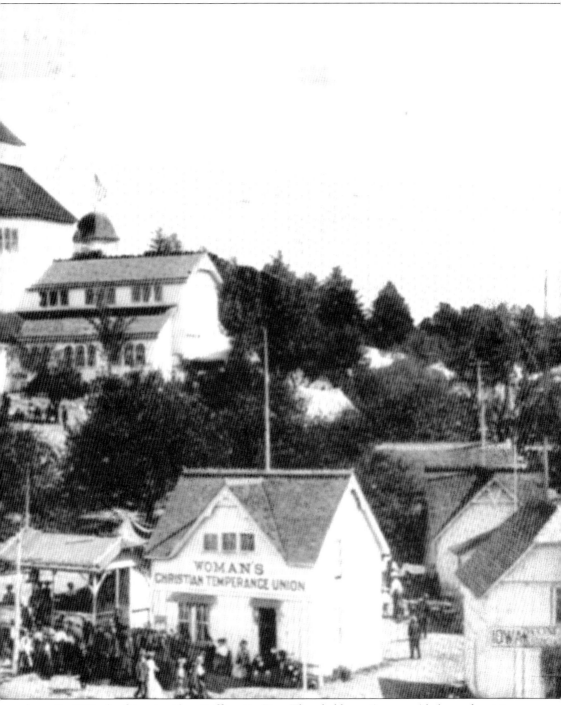

them. In 1910, the fair set aside a Suffragette Day. They held meetings presided over by state president Julia Clark Hallam of Sioux City. The year 1910 was also the year that W. B. Barney, state food commissioner, found that cider men at the fair were selling adulterated cider made with water, brown sugar, and a little vinegar. They were given their choice—leave the grounds in 30 minutes or face prosecution. They left.

A view along Grand Avenue shows a mix of automobiles and horses and buggies. By 1913, Iowans owned 75,000 automobiles, and lack of space for them was a big concern for fair management. The good condition of country roads, combined with no reduced railroad rates, caused "every street and available corner to be lined with autos." The congestion was relieved a little when the space reserved for the Tama Indian Exhibit near the Rock Island entrance was turned into parking. The Tama Indians did not come to terms on their exhibit, and were dropped at the

last minute. Some auto drivers boycotted the Burlington Railroad because they refused to lower rates to the fair, including one group from Creston with 93 automobiles. Fairgoers went scurrying when Dr. Nelle Noble left her big automobile in a hurry, neglecting to set the brakes. The automobile ran wild down Grand Avenue and rammed into the Agriculture Building. "The bricks refused to budge, and as a result, the machine was badly damaged."

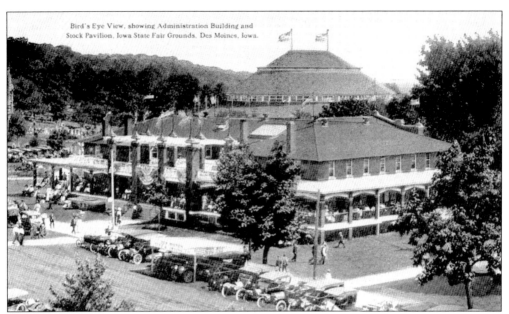

Shown here is a view of the 1913 Iowa State Fair. Opening day was designated as Children's Day, but the children were disappointed because the midway had not yet arrived. August 26 was designated Old Settler's Day. Anyone who lived in Iowa prior to December 28, 1846, (when Iowa became a state) was admitted free. As it turned out, there were many people that claimed to be the oldest settler in Iowa.

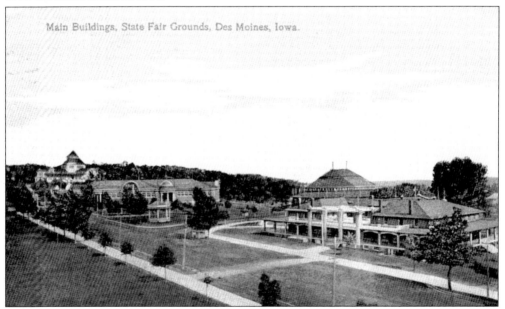

This is another 1913 view, the year that reformer John Hammond asked safety superintendent E. M. Wentworth to close down an immoral "hoochie-coochie" show on the midway. Hammond said that he and three Civil War veterans attended a performance, and would swear the show was illegal. An exhibit of canned goods stored at the fair was discovered to be missing many jellies and fruits. An investigation found that during the summer, workmen "had made serious inroads upon the edibles."

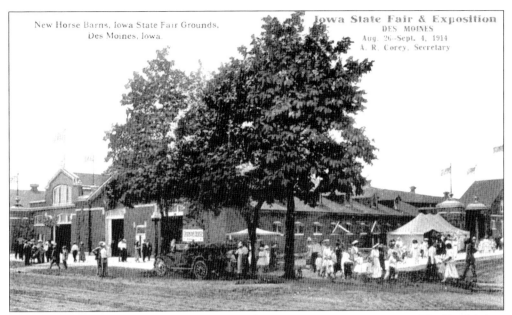

New Horse Barns, Iowa State Fair Grounds,
Des Moines, Iowa.

Iowa State Fair & Exposition
DES MOINES
Aug. 26–Sept. 4, 1914
A. R. Corey, Secretary

This card advertises the 1914 Iowa State Fair, when A. R. Corey was secretary. The Des Moines Register and Leader set up a wireless station at the fair, and became the first Iowa newspaper to receive a wireless message. On August 31, at 8:00 p.m., a heavy windstorm struck the fair, injuring a dozen in the crowd of 30,000, and causing considerable property damage to concessions and tents.

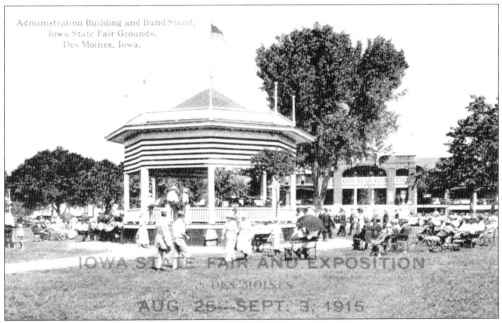

Administration Building and Band Stand,
Iowa State Fair Grounds,
Des Moines, Iowa.

IOWA STATE FAIR AND EXPOSITION
DES MOINES
AUG. 25–SEPT. 3, 1915

The Band Stand in this 1915 view was south of the Administration Building where the Bill Riley stage is today. The midway, managed by The World at Home, included Wilson and Taylor's Animal Circus, California Frank's Wild West Show, and Cora Beckwith and her Diving Girls. The 21-year-old daredevil pilot Art Smith performed his "aerial insanity" in daily Grandstand shows, including a "loop-the-loop" at night with fireworks.

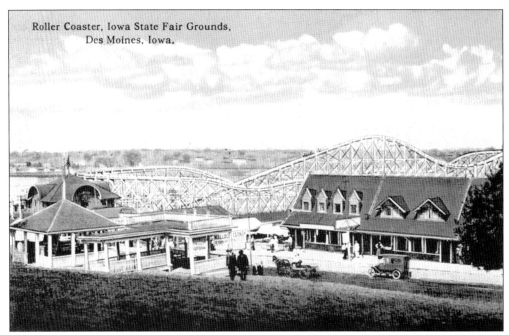

Roller Coaster, Iowa State Fair Grounds,
Des Moines, Iowa.

In 1915, a wooden roller coaster that was 3,200 feet long, and gave a ride of over a half mile, was built northeast of the Grandstand. It was reported that many state fairs had a "similar apparatus, but none of them are longer than this one." The Keenans of Oklahoma City, who owned Ye Old Mill, owned the coaster. They leased the space from the fair on a basis of 25 percent of admissions.

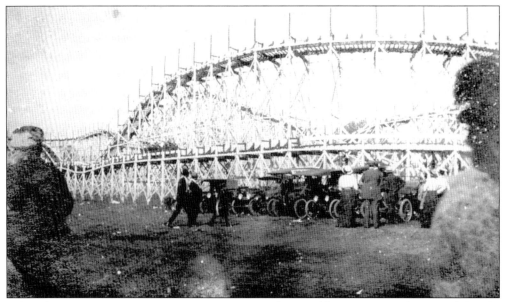

When the Iowa State Fair was set to reopen in 1946 after World War II, it was discovered that the footings on the coaster were rotting. Lumber was in short supply after the war, so rather than repair the ride, the owners made the decision to tear it down. It was sold to A. R. Corey, the former fair secretary, who dismantled it and sold the lumber to house-builders in the Des Moines area.

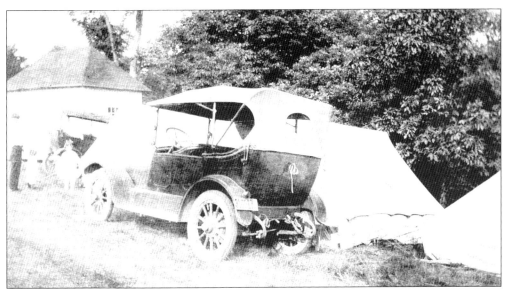

In this 1916 campground view, "Uncle Will" parked his automobile by his tent. By 1916, Iowa had over 185,000 automobiles, 5,000 of which came to the fair on a busy day. Campground superintendent M. W. Keating said that more camping tickets had been sold on the first weekend than at the entire 1915 fair. "Hucksters, grocers, icemen, and milkmen" made their daily rounds through the camp with their provisions.

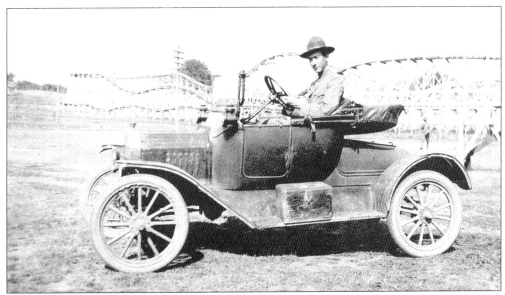

In this 1917 photograph, a soldier poses in his Ford Model T near the roller coaster. Also at the 1917 fair, 1,200 "Colored Soldiers" from the Officer's Training Camp at Fort Des Moines appeared, and performed drills and evolutions. The Woman's Committee of the National Council of Defense met in the Women's and Children's Building to learn what women can do in time of war.

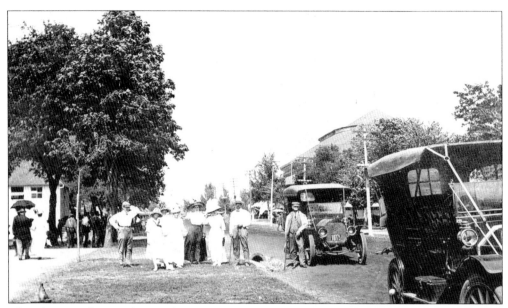

This photograph was taken at the 1917 Iowa State Fair, when the United States was in World War I. Iowa's first regiment to be ordered to France, the 3rd Iowa Infantry passed in review before the Grandstand. The entire half-mile racetrack was filled with 4,000 troops, and took 15 minutes for all to pass. They were being mustered into federal service as the 168th U.S. Infantry, and would become part of the 42nd "Rainbow" Division.

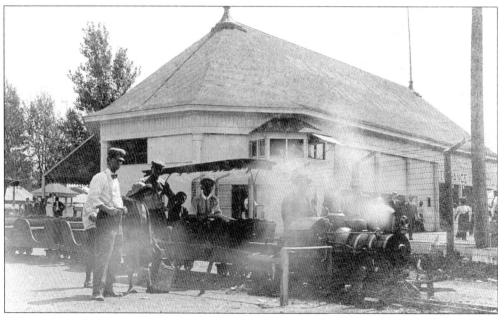

The 1911 Iowa State Fair program stated "For the amusement of little folks there will be a new feature in the shape of a miniature railway which will make regular round trips starting from a station immediately north of the streetcar entrance, and running west through the machinery exhibit and return." The building shown here, identified by a sign on the roof, is the "Des Moines City Railway Co. State Fair Entrance."

One of the Morris and Castle Shows at the 1926 fair was the Midget Theatre consisting of "five little midgets assembled from all parts of the globe, all performers, entertainers, singers, musicians, or dancers." Two of them were Mrs. Doefler and daughter Angeline, billed as "the world's only living midget mother and daughter." The mother was 54 years old and 26 inches tall, and the daughter was 25 years old and 28 inches tall.

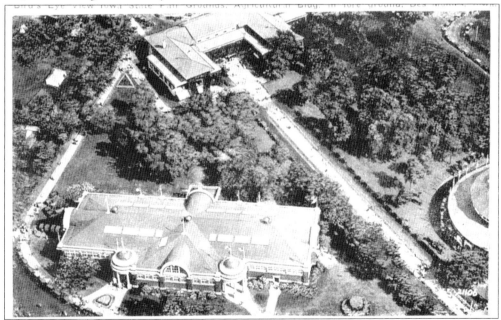

This 1926 card shows the Agriculture Building, and Women and Children's Building. The year 1926 saw the first annual Iowa 4-H Club Congress. Demonstrations by the girls' teams were held in the Women's Building. Demonstrations by the boys were in the Cattle Barn, with exhibits in the west balcony of the Agriculture Building. Other Agriculture Building shows included the official Midwestern show of the American Gladiolus Society, with 500,000 blooms.

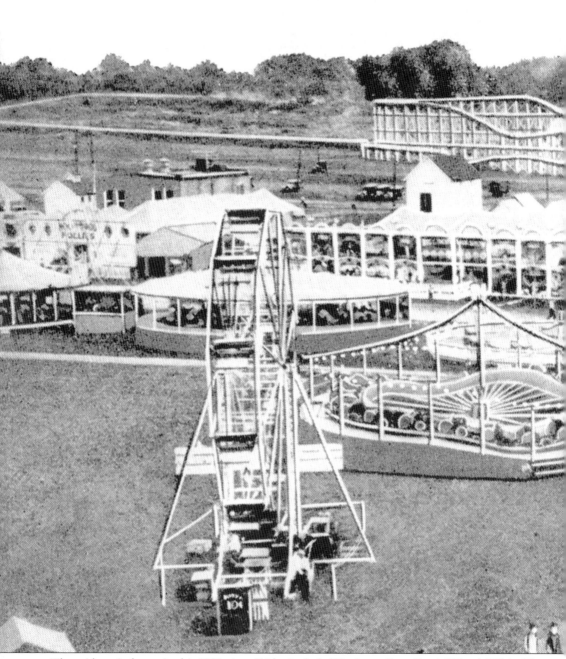

The midway is shown in this 1929 view. Rides included Dodgem Cars, Ferris Wheel, Whip, Hey Dey, Caterpillar, Dangler, Merry-Go-Round, Lindy Loop, and Bug House (house of mirrors). At the Motor Drome, motorcycle daredevils raced around wooden vertical walls, with a lion prowling around beneath them. Sideshow acts included a woman who climbed into a small box, which was then pierced with swords. One would have to pay extra if they wanted to peer into the box to see how she survived. In another act, a woman had oil poured on her, and was then

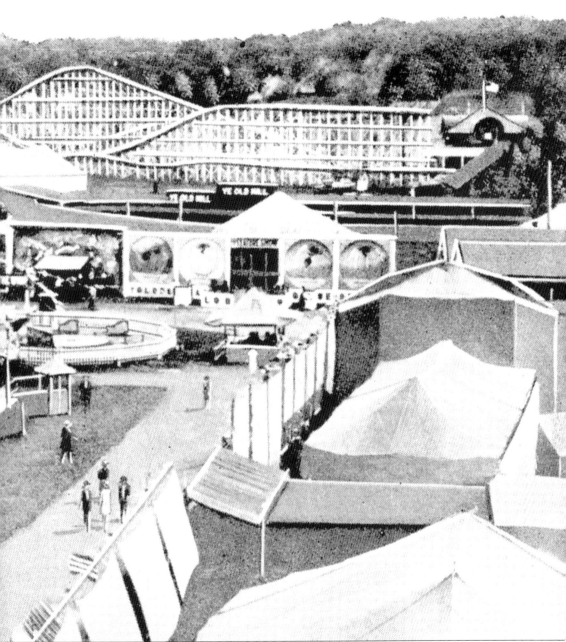

set on fire in a coffin. In still other acts, a woman was shot through her chest with a marked bullet, and a magician levitated a woman several feet above a table. The Monkey Speedway had monkeys racing automobiles around a banked circular track, and the Freak Animals tent included a two-headed calf. Wax figures of U.S. presidents were shown in the Hall of Fame, and a baby shown at various stages before being born was at The Unborn. Other sideshows were Minstrels, Wild West Show, Musical Maids, and Fun on the Farm.

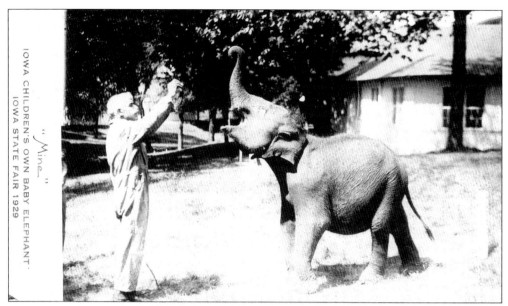

IOWA CHILDREN'S OWN BABY ELEPHANT. "Mine." IOWA STATE FAIR 1929

In 1929, thousands of Iowa children contributed their dimes to buy a baby elephant, and named her Mine. On August 23, opening day, 25,000 children came to see her christened in a pink and white baby dress. When the fair closed in 1942 for World War II, Mine was sold to the Cole Brothers Circus who renamed her Katie. The statue, *Baby Mine*, stands today in the Fun Forest east of the Agriculture Building.

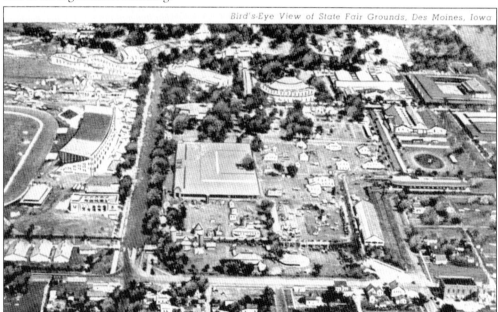

Bird's-Eye View of State Fair Grounds, Des Moines, Iowa

The fair's Diamond Jubilee, which set all-time attendance records up to that time, is shown here in this 1929 aerial view. Four-foot square diamonds, made from plate glass mirrors and illuminated by lights, were erected on six buildings. Because of Prohibition, concessions sold "near beer." Bill "Daredevil" Harris, billed as the only "Negro parachute jumper" in the country, made daily jumps. The fair closed with a mock "Battle in the Sky," involving cavalry, artillery, and airplanes.

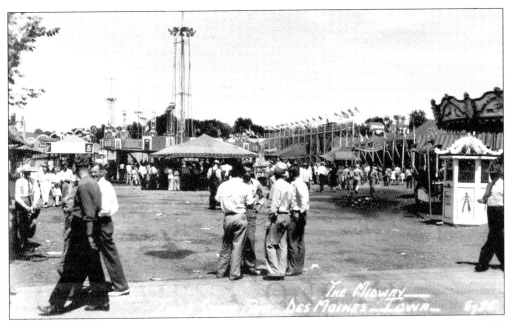

In 1946, the midway was operated by Hennies Brothers Shows. In 1947, the famous fan dancer Sally Rand appeared in the midway. In this midway view from the late 1940s, the merry-go-round is visible on the right side. Just to the left of center is the live mouse game, in which bets were made on which colored or numbered hole the mouse would scramble down.

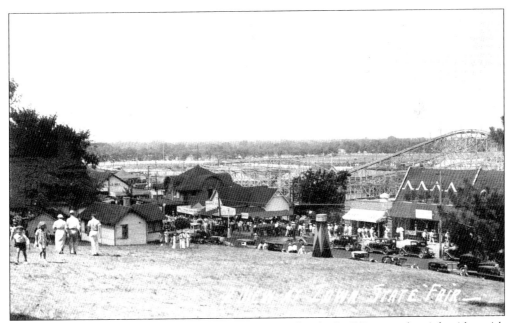

This 1937 view looks northwest from Exposition Hill. The building on the right side, with the awning, was the post office. In recent years, it houses a soda fountain. Automobile and motorcycle daredevils performed at the Grandstand Thrill Show. F. F. "Bowser" Frakes performed a spectacular stunt by crashing his airplane into a frame house. It was an unadvertised surprise, as it was feared that aeronautics inspectors would stop it.

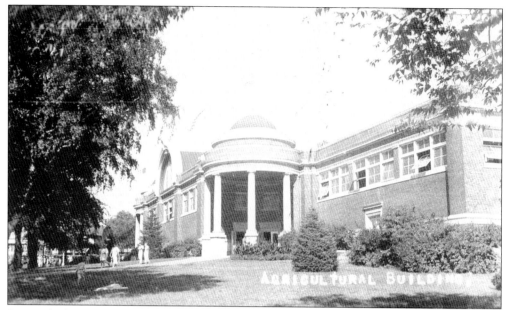

Postmarked in 1939, the sender of this card had a common fairgoer lament "I am having a fine time, only I am always tired!" In 1939, movie star Susan Hayward appeared at the Register and Tribune State Fair Contest to select a "Queen of Iowa Redheads" from 25 contestants. The winner was Margaret Leeper of Waterloo. Big bands at the Dance Pavilion included Paul Whiteman and his Chesterfield Orchestra, Don Bestor, and Abe Lyman.

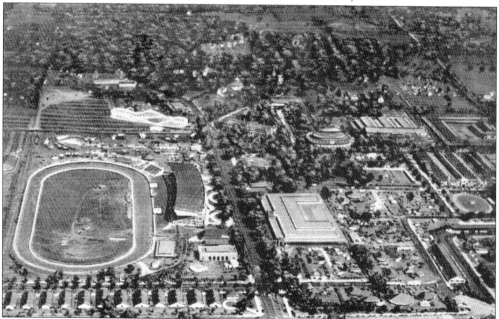

The 1940 Iowa State Fair is shown in this aerial view. Attendance was down 40,000 from 1939 due to rain. The muddy track forced cancellation of all horse races, Thrill Days, and all but one day of automobile races. The Pavilion Horse Shows drew capacity crowds, probably to keep dry. At the assembly tent, Ida B. Wise Smith, WCTU national president, condemned "peep shows." Big bands at the Dance Pavilion included Johnny "Scat" Davis, Anson Weeks, and Louis Armstrong.

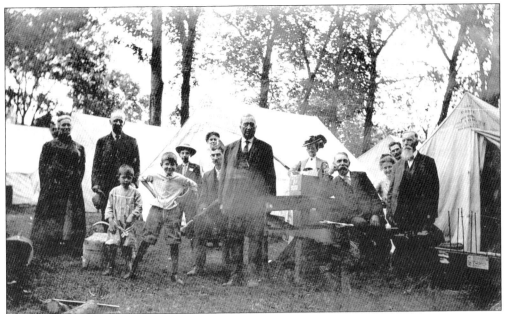

In 1886, when the fair was moved permanently to its present location, 160 wooded acres on a hill in the northeast section of the fairgrounds was designated as the campground. This view shows a group of fairground campers in the early 1900s. Camping was free, and if you did not have your own tent, you could rent them from Des Moines Tent and Awning, as did these campers.

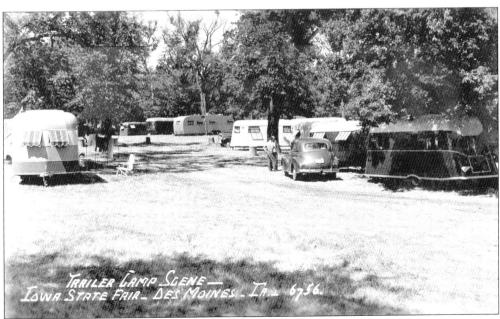

By the 1930s, about one-fourth of all fairgoers camped here. In 1936, a section of the campgrounds was set aside for "tourist trailers." The trailer camp was the first of its kind at a Midwestern state fair. This view of the trailer camp is from the 1940s. Today, there are more than 1,800 campsites with electricity and water, nearly 600 sites with sewers, and several hundred more without utilities.

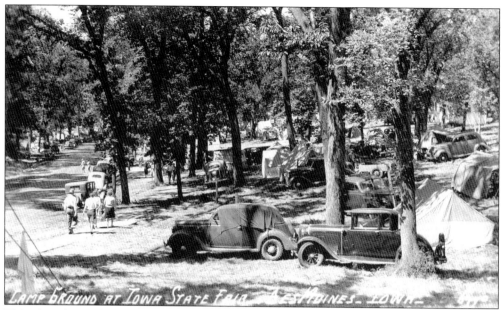

This view shows the campground in the 1930s. In the early 1900s, the fair board began giving campers permission to build permanent concrete tent decks at their own expense, and use the same camping space each year. Some families used the same tent deck over several generations! Even though they did not have legal title to the land, they sometimes sold their camping spaces for several hundred dollars.

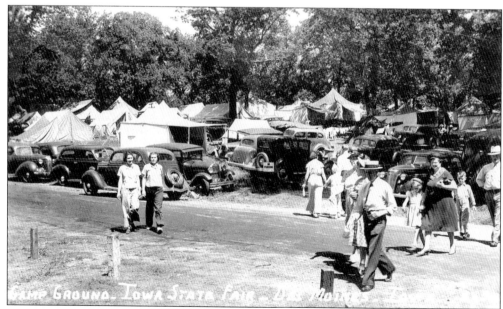

Another view of the campground is shown in this 1930s postcard. In November 1966, an outcry was raised when fair board secretary Kenneth Fulk proposed breaking up the 283 permanent tent decks, and turning the area into a parking lot. Longtime campers complained vigorously, and appeared at a statehouse meeting with Iowa legislators and fair officials. The campers lost their argument, and the tent decks were eventually demolished.

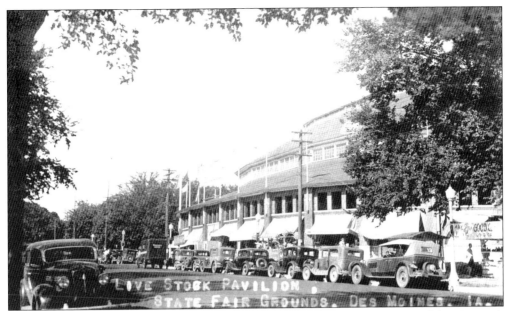

In this late 1930s view, arched alcoves shaded by awnings circle the exterior of the Livestock Pavilion. These alcoves were, and still are, used by concessionaires during the fair. A Zinsmaster's Bread truck is seen making its deliveries. Zinsmaster proudly advertised in fair programs that "Master Bread is made with rich malted milk." On the right side in this view, Mae's Lunch sold "Good Coffee and Cold Drinks."

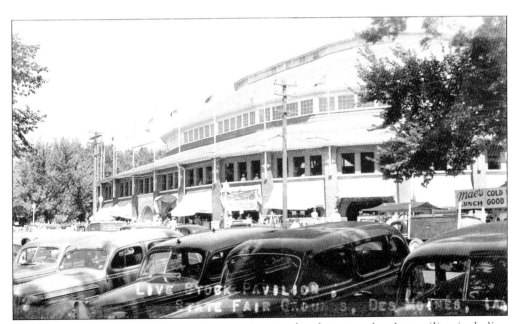

The Livestock Pavilion in 1939 had concessions in the alcoves under the pavilion including Reed's Ice Cream, a local favorite, selling 10¢ Malted Milk Shakes, and 5¢ Reedette Sundaes. They were one of longest running concessions in the Pavilion, in the same spot from the 1920s to the 1960s and beyond. Other Pavilion concessionaires in 1939 included Gannon's, B&G Lunch, Sam Cohen Cigarettes, A-C Ice Cream, and Central Church of Christ.

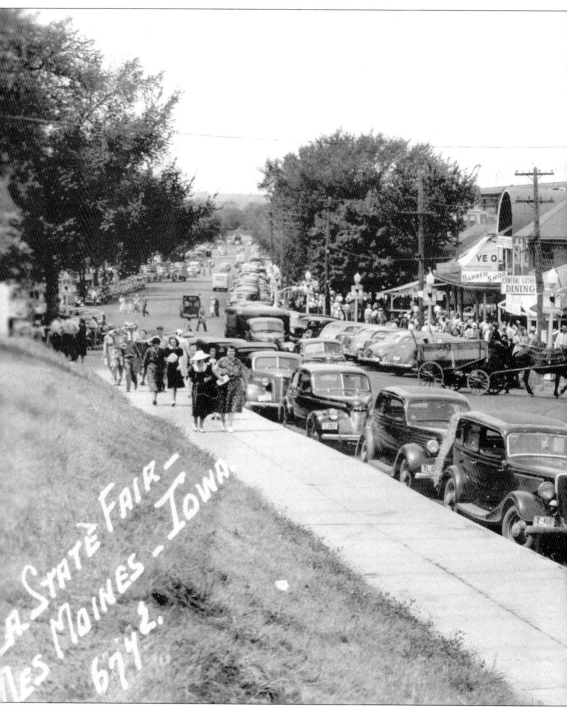

This view at the 1941 Iowa State Fair is looking west on Grand Avenue from the vicinity of where Heritage Village is today. On the right side, a Coca-Cola truck goes by the post office. Looking west from the post office is the Coney Island food stand selling 10¢ Hamburgers, 5¢ cold drinks, and Furnas Ice Cream; Cook's Food stand selling Hot Dogs, Hamburgers, and Meadow Gold Ice Cream; Clair Beattie Sandwiches and Drinks; Talbot's Dining Hall; and Central Lutheran

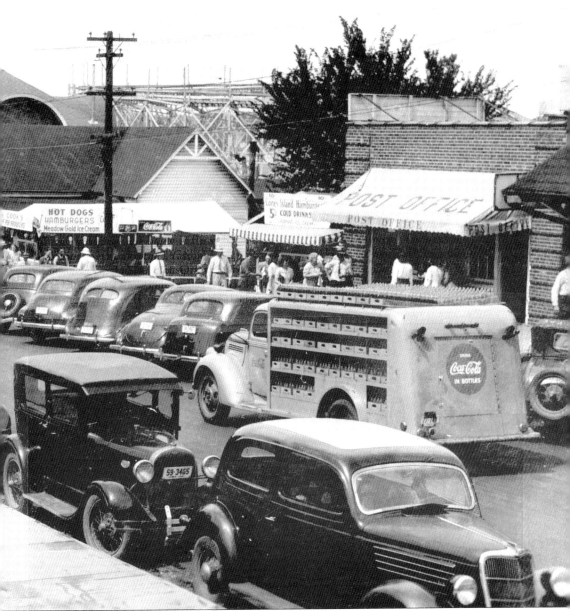

Church Dining Hall. Next is the Dodd and Struthers Building, a brick and tile building that housed their lightning rod exhibit in the early 1900s (center with the flag on top, where the beer tent is today). In 1941, Habelitz's melons and fruits had the concession on the first floor, and Joe Coleman's Barber Shop was on the second floor. In later years it was sometimes called the "watermelon building." In the 1950s it was torn down, along with Talbot's Dining Hall.

World War II was in progress when this photograph was taken in 1941. Although it was not known at the time, this would be the last fair until 1946. A victory arch was erected on the main gate, and flags and patriotic slogans were displayed on many buildings. There were air raid lectures, and wire service dispatches on the Siege of Leningrad in the Register and Tribune Building.

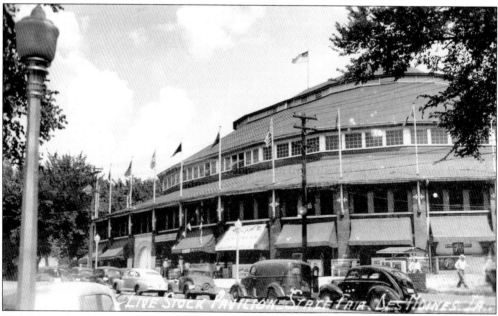

This is another view of the 1941 fair. The U.S. Army paraded their vehicles in front of the Grandstand, and gave combat exhibitions. There was also an army exhibit in the Varied Industries Building, across the aisle from an anti-war exhibit by the Socialist Labor Party of America. Barnes and Caruthers State Fair Revue *Music on Wings* featured Nirska performing *Dance of the Butterfly*, and Harold and Lola performing *The Cobra and the Charmer*.

In 1941, the author's mother-in-law, Anna Simper of Garner, seen here at 19 years old, won first prize for white bread at the fair. She also won two additional first place ribbons, three second place ribbons, and three third place ribbons in other culinary contests. In 1999 (after not entering for 39 years), Simper was persuaded to enter her angel food cake, chiffon cake, and cinnamon rolls. In a remarkable feat of longevity, she won blue ribbons for her angel food and chiffon cakes.

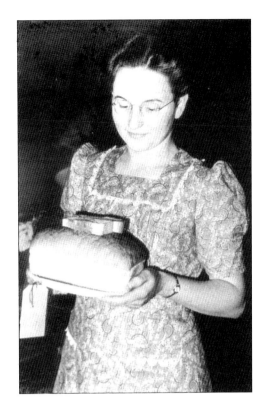

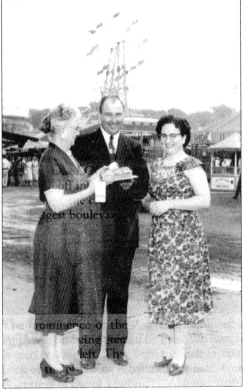

Simper (now Anna Falada) continued winning ribbons for her culinary entries in the ensuing years. In 1959, she won a special "Best-of-Show" diamond-studded gold ribbon pin for her "Anniversary Cinnamon Rolls." The award, from Fleischman's Yeast, was for the entry judged best from all classes of yeast-raised bread, sweet bread, or rolls. Anna (right), along with her husband, Francis, received the award from Agnes Dwyer, superintendent of the Culinary Department. The midway and Ferris wheel can be seen in the background.

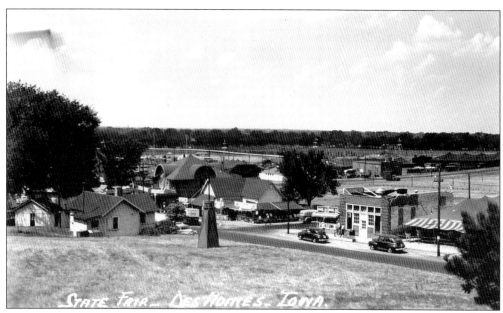

This view in 1946, of the first fair since 1941, looks northwest from Exposition Hill. During World War II, the Army used the fairgrounds as a storage and supply depot. The year 1946 was the centennial of Iowa's statehood, and there were many exhibits at the fair showing how Iowa had lived 100 years ago. An estimated 25,000 people saw *Vox Pop*, a popular nationwide radio quiz show that traveled America, broadcast a show from the Band Stand. The hosts were Parks Johnson and Warren Hull.

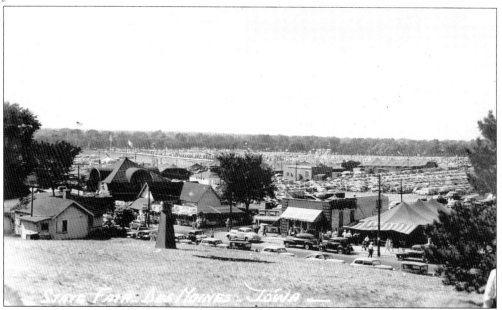

Shown here is another view from 1946. At the International Harvester exhibit, KRNT gave television demonstrations and broadcast closed circuit television shows. Bill Riley was the announcer, and Russ Van Dyke made his television debut as newscaster. A single day attendance record of 89,295 was set on Sunday, August 25, 1946. That same night, the forage barn, on the southeast corner of the fairground, burned to the ground losing 15,000 bales of hay.

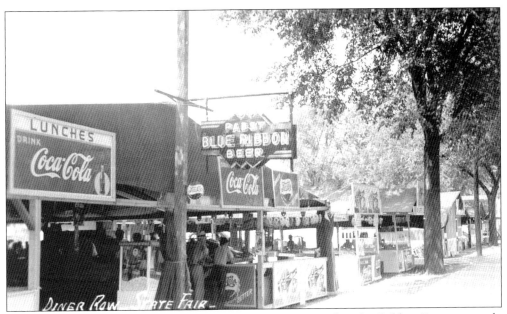

Concession stands in the late 1940s, including this one selling Pabst Blue Ribbon Beer, were only allowed to sell four percent beer. Concessionaires of this era included several familiar names: Leo Zagnoli, Mary Hardenbrook, and Melvin Little (who started the business that would later become Campbells Concessions). Curtis Yocum, whose last name was the same as a popular comic strip character, opened Little Abner's Old Hickory House on Grand Avenue.

This 1948 view looks east on "Main Street" (Grand Avenue) from near the west end of the Grandstand. Admission prices in 1948 were 50¢ at the gate, with children under 12 free. Automobiles or horse drawn vehicles were also 50¢. Grandstand seat prices ranged from 60¢ to $1.50. Admission to the Horse Show at the Stock Pavilion ranged from 50¢ to $1.50.

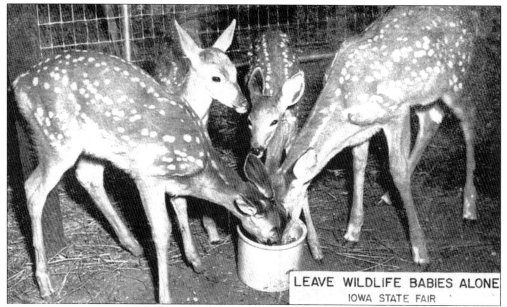

LEAVE WILDLIFE BABIES ALONE
IOWA STATE FAIR

Cards from the Fish and Game Building in the early 1950s had the theme "leave wildlife babies where they belong—at home in the wild." Information on the back of the cards explained how baby wild animals were taken from their homes and illegally held as pets by "wildlife kidnappers" until they were rescued by conservation officials. Animals raised in captivity lose their fear of man and become nuisances, even dangerous.

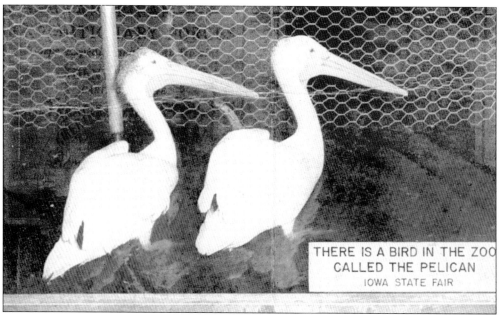

THERE IS A BIRD IN THE ZOO
CALLED THE PELICAN
IOWA STATE FAIR

Shooters, who did not know or care that pelicans are protected in Iowa, crippled the pelicans shown here. The wildlife cards in the author's possession (and others the author has seen) all have two-cent stamps applied, whether used or unused. This, and the fact that they are thicker than regular postcards, leads the author to believe they were dispensed from vending machines, similar to the penny arcade machines of that era, with the stamps already applied.

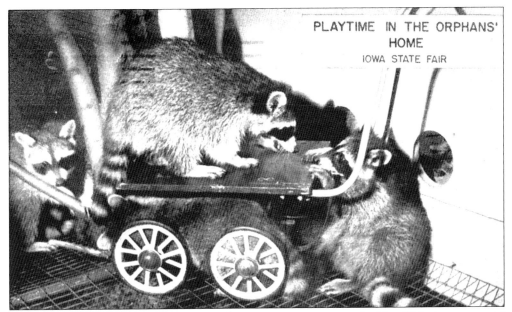

This card of raccoons playing in the Orphans' Home, was postmarked in 1954, the centennial of the fair. To commemorate the centennial, a caravan with covered wagons, horse-drawn buggies, and riders on horseback traveled from Fairfield, the site of the first fair in 1854, to the Des Moines fairgrounds. Pres. Dwight Eisenhower and former Pres. Herbert Hoover visited the fair. A time capsule was buried on the fairgrounds to be opened in 2054.

RACCOON ORPHAN'S HOME
IOWA STATE FAIR

In 1954, while the raccoons were playing, the Sylpha Snook Players performed in the Women and Children's Building. Ralph Zarnow and his Orchestra played at the Dance Pavilion. Gene Autry and his horse Champion appeared at the Championship Rodeo. Barnes and Carruthers presented an outdoor musical revue with a cast of 150, and Thrillcade with Aut Swenson and his automobile daredevils, performed stunts with a fleet of new 1954 Fords.

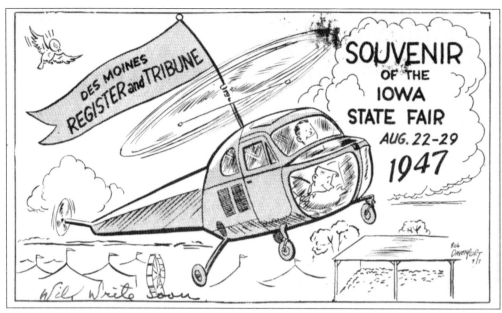

In 1947, as an advertising stunt, the Des Moines Register and Tribune brought a Bell Helicopter to the Iowa State Fair. The pilot was Bob Angstadt, an ex-army air force captain from St. Louis. On opening day, Angstadt picked up Gov. Robert Blue at the statehouse, and flew him to the fairgrounds Grandstand. On the following days, he picked up other dignitaries including the mayors of Marshalltown and Newton.

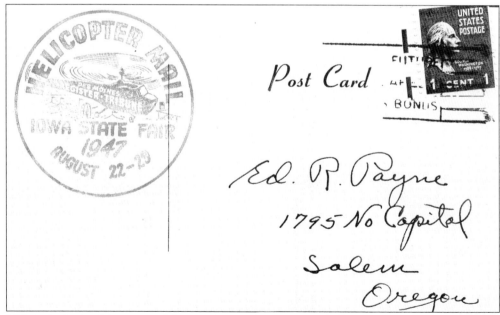

This is the back of the postcard shown above. They were available at the Register and Tribune exhibit at the fair, and could be mailed as "Helicopter Mail." They would be collected daily and flown downtown by the helicopter, landing on Eighth Street between Keo Avenue and Pleasant Street. The helicopter would drop off the mail, give a short demonstration, then return to the fairgrounds.

Two

THE GRANDSTAND

SHOWS, EXTRAVAGANZAS,

AND DAREDEVILS

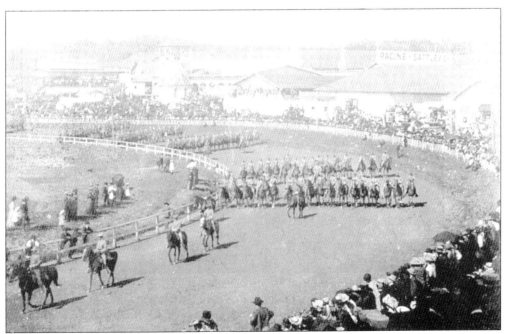

In 1904, the 11th Cavalry from Fort Des Moines gave demonstrations and drills at the Grandstand. They made an impressive sight while marching in formation around the track and passing in review. There were Roman Races with each trooper standing on the backs of two horses, a Cossack Charge between two troops with soldiers standing in their stirrups, and Rescue Races with horsemen dashing to a fallen soldier, jerking him onto the horse, and dashing to safety.

Race Track and Ampitheatre, Iowa State Fair

This view of the old wooden grandstand was postmarked in 1906. The previous grandstand was destroyed in 1892 by a storm. Grandstand entertainment in 1906 included the following vaudeville and novelty acts: The Pekin Zouaves, a group of 17 military men, performing wall-scaling and drills; Castellane and Volo, billed as "the most daring bicycle act ever seen," performed the "Double Gap of Death;" Scottish bagpipers; performing elephants; and Liberati's Military Band.

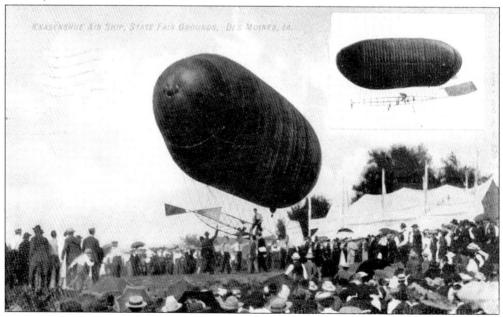

The big attraction in 1906 was "the most sensational feature of any fair ever held in Iowa," the flights of the Knabenshue Airship piloted by Charles K. Hamilton. When he made his first flight, "men refused to believe their eyes and children stood in amazement." This view shows the airship near its tent on the hill east of the racetrack and north of the dining halls on Grand Avenue.

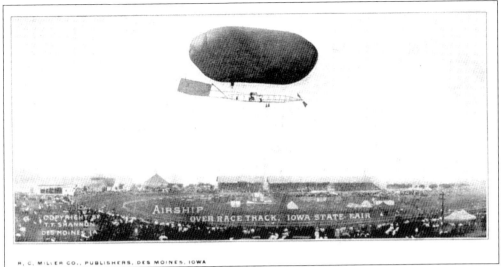

Roy Knabenshue built the airship, shown here over the racetrack. He did not accompany his balloon to the fair because he had not fully recovered from a fall into a lake the previous month. Knabenshue was not only an aeronaut of balloons and dirigibles, but was also a designer, builder, and exhibitor of airships that were piloted by many pioneer aviators. He later became exhibition manager for the Wright brothers team.

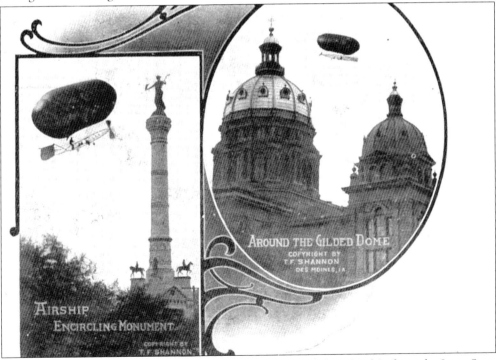

On August 27, 1906, Charles Hamilton piloted the Knabenshue Airship from the Iowa State Fair fairgrounds to the Iowa State Capitol Building and back again. He landed on the capitol grounds, and while waiting for the gasoline engine to cool, had lunch at the home of G. D. Ellyson, fair treasurer. He then flew twice around the soldier's monument and the capitol dome before going back to the fair.

SOUVENIR

The First Photograph Ever Taken from the

CLOUDS

Taken by Chas. K. Hamilton from his Air Ship, Des Moines, Aug. 29, 1906.

"The First Photograph Ever Taken from the Clouds" proclaimed this aerial view of the fairgrounds from the Knabenshue Airship. An article in the August 30, 1906, *Des Moines Register & Leader* proclaimed, "For the first time in the world's history, photographs of the earth were taken from an airship yesterday. At a height varying from 300 to 600 feet, the daring navigator of the air, Charles K. Hamilton, successfully took several photographs above the fairgrounds. While it is a fact that photographs have been taken from balloons and aeroplanes, never before have they been successfully taken from an airship. The feat demonstrated the superb control the aeronaut had over his airship to hold it steady. While the Register & Leader takes considerable pride in being able to publish the first pictures which were ever taken from an airship in the world's history, the credit is due to Mr. Hamilton, who graciously risked his life to accomplish this feat."

The new $100,000 steel amphitheater was built in 1909 to replace the old wooden grandstand. A 1906 newspaper story reported that "the need of a new steel grandstand was forcibly illustrated yesterday when the old stand was packed full long before half the people had been accommodated." A new racetrack was built further west than the old one. Nightly entertainment included Pain's Pyrotechnics fireworks war spectacle *The Battle in the Clouds*.

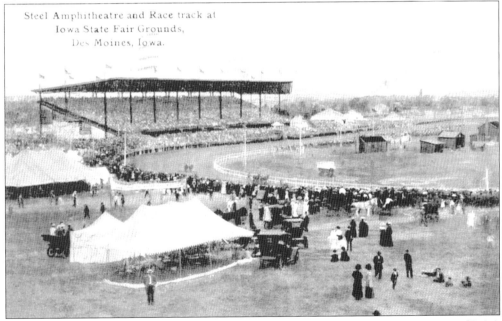

The log cabins and other buildings in the racetrack infield in this 1910 view were part of Pain's Pyrotechnics nightly spectacle, *Frontier Days in Iowa*, using 250 performers. The opening scene showed settlers working in the fields. After Native Americans attacked them, soldiers from the nearby fort arrived, but too late to prevent the fiery destruction of the settlement and farm homes, reenacted in a blaze of fireworks.

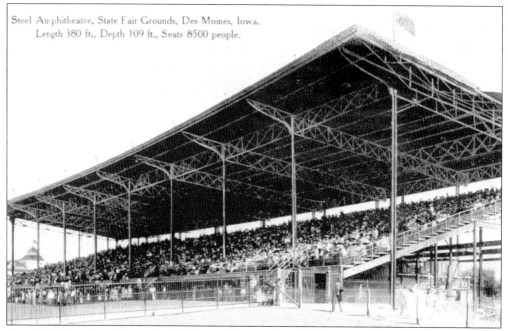

Steel Amphitheatre, State Fair Grounds, Des Moines, Iowa.
Length 380 ft., Depth 109 ft., Seats 8500 people.

The 1911 Grandstand shows included musicians and vaudeville acts: The Galt Kiltie Band from Ontario Canada, the Borsini Troupe of equilibrists, the Macarte Sisters (trapeze and high wire artists), and Prevost and Brown comedy acrobats. Allie Wooster's four-mile relay horse race used three women who changed horses each mile. Ray Harroun in his Marmon Wasp, the winner of the first Indianapolis 500, appeared in an exhibition auto race.

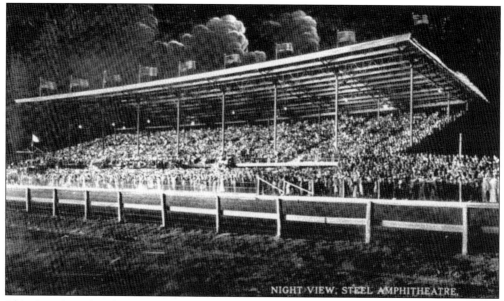

NIGHT VIEW, STEEL AMPHITHEATRE.

This Grandstand night view was postmarked August 31, 1914. One of the Grandstand acts that year was Hankinson's Auto Polo. A local newspaper said that Ralph Hankinson arrived in town with a broken arm. That may have been what Lyle, the sender of this card referred to, when he wrote "I have not been hurt, but one of the boys broke his arm and another is in the graveyard and one is in the hospital."

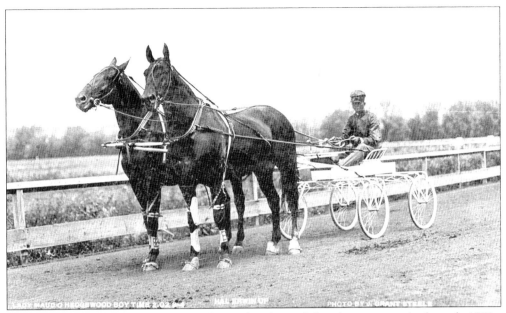

Lady Maud C. and Hedgewood Boy, a famous brother and sister harness team in the early 1900s, were good at teamwork. Earlier in their lives they had pulled plows together. In 1910, when this postcard was postmarked, the M. W. Savage stable brought five horses to the fair, including Dan Patch. In one of the feature races, Lady Maud C., driven by Hal Erwin, beat her stablemates Hedgewood Boy, Minor Heir, and George Gano.

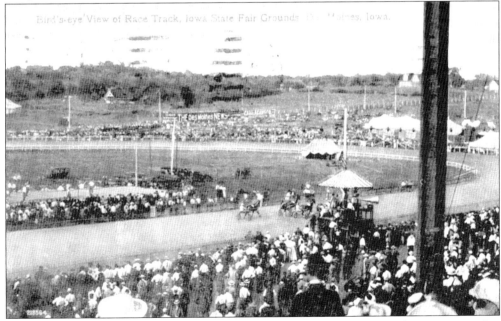

This view of the harness races was postmarked in 1914. The big Grandstand extravaganza that year was Pain's Pyrotechnics *Opening of the Panama Canal* presented on a 400-foot stage with 300 performers. There were vaudeville and novelty acts including a 40-girl ballet, The Seven Bracks, The Four Casters, Navarose Comedy Acrobats, The Alexine Troupe, Adas Troupe, The Three Zachs, The Five Gargonis, and Four Portia Sisters. It concluded with a spectacular fireworks show.

A man and boy hang over the fence of the racetrack in this 1910 view, enjoying a free look at the horse races. Along with exhibition races by horses from the Savage stable, other races were held. Daisydale won first place for two-year old trotters, with a $500 purse for the best two out of three races. Countess Marie won first for three-year old pacers, with an $800 purse for the best two out of three races, and Lady Jane Etta came in second place.

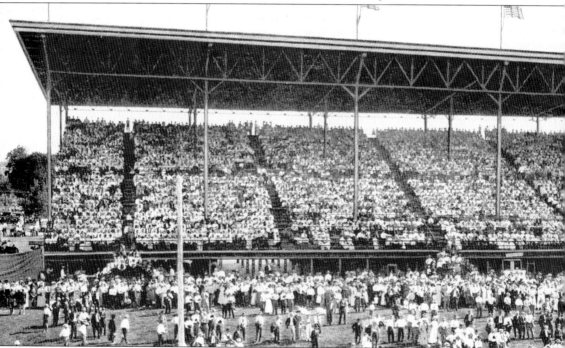

This double-wide panoramic postcard of 1913 shows a packed Grandstand and overflow crowd standing in front. The Grandstand shows in 1913 were well attended, filling even the bleachers to the west of the main Grandstand. Shows that year included harness races with specialty and vaudeville acts between heats. Some of the specialty acts were Carver's High Diving Horses, which included a girl in red diving on a horse from a 40-foot platform; Rollo the Limit

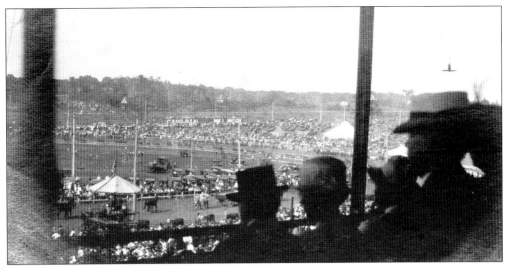

Shows in 1914, when this photograph from the Grandstand was taken, included horse and automobile races, evening shows "The World's War" and "Our Boys Over There," military drills with soldiers from Camp Dodge, and Broncho Busters from Montana in wild-west horse riding exhibitions. Allied aviators put on a spectacular afternoon air show with mock battles. Other Grandstand acts were Monahan and Company Roller Skaters, Twelve Tally Ho Girls, and the Larned and Kaufman Comedy Bicycle Act.

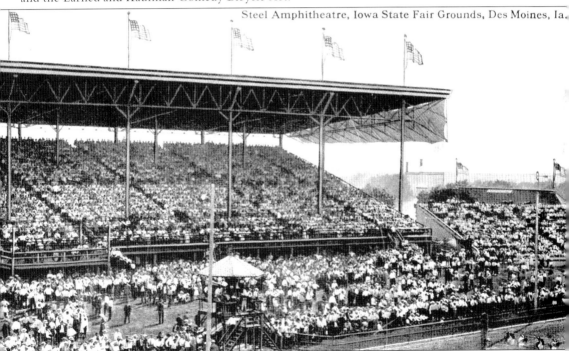

loop-the-looping on roller skates; Slayman Ali's Troupe of Arabian Acrobats; and Marvelous Wenton, who allowed a 7-passenger automobile to drive over him. Night shows included a concert by Liberati's Band and *Old Mexico 1847*, Pain's Pyrotechnics extravaganza depicting the storming and capture of Mexico City using spectacular fireworks and hundreds of performers.

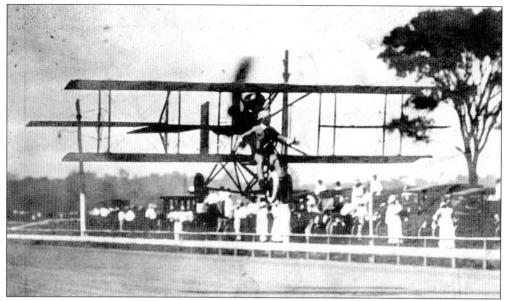

Lincoln Beachey, the era's most popular daredevil aviator, was paid $1,000 a day to appear at the 1914 Iowa State Fair. He made daily exhibitions before crowded grandstands, flying upside down, loop-the-loops starting at less than 1,000 feet, and other stunts. One spectacular stunt was his death dive, where he turned his plane upside down at 4,000 feet, then dove straight down towards the ground at full speed before pulling up at the last second.

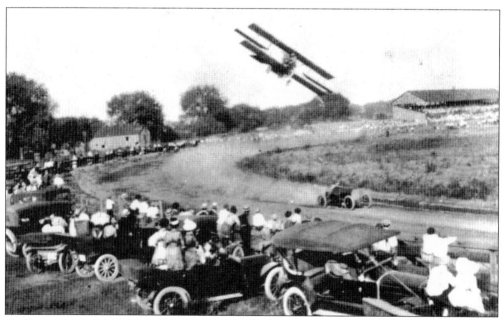

On September 4, 1914, Lincoln Beachey raced his biplane around the racetrack against a Duesenberg automobile driven by Eddie Rickenbacker, who later became a World War I flying ace. Beachey, flying as close as 10 feet to Rickenbacker's automobile, agreed to circle the track four times to Rickenbacker's three, giving him a head start of one lap. Rickenbacker won the race. His three laps were clocked at 1:45.48, Beachey's four laps were clocked at 1:50. (Courtesy State Historical Society of Iowa.)

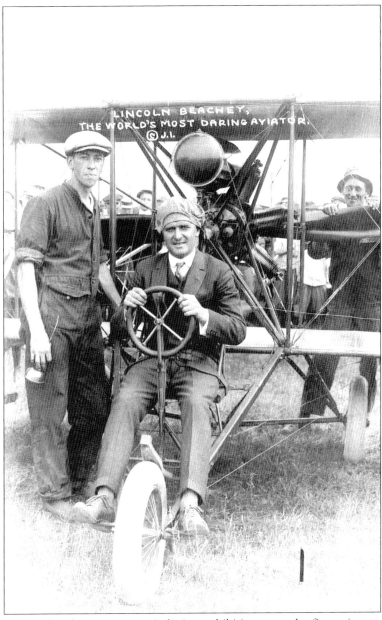

Lincoln Beachey, who always wore a suit during exhibitions, was the first aviator to fly upside down, and the first to perform the loop-the-loop in America. Orville Wright once referred to him as "the greatest aviator of them all." Beachey entertained more than 17 million people in 126 cities from November 1913 to November 1914, and earned an estimated $250,000. In an interview in Des Moines, Beachey said he would quit when he made $1 million, providing he was not made to quit before "due to a flaw in the steel or a weak support in his machine." He said if his "end comes by a drop in the sky," he wants it to be a "big drop and a quick stop." Unfortunately, that is exactly what happened six months later. He was killed on March 14, 1915, while he was flying a newly designed monoplane at the Panama-Pacific International Exposition in San Francisco. While performing a stunt dive, the wings on his airplane broke away, and he dove at full speed into the San Francisco Bay. He was only 28 years old.

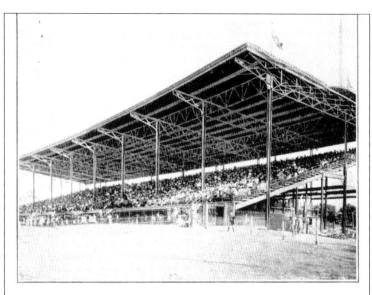

VIEWS ON IOWA STATE FAIRGROUNDS

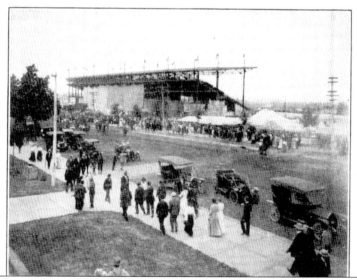

In 1919, when this photograph was taken, the streetcar strike ended just in time for the first day of the Iowa State Fair. City officials approved a 6¢ fare for nine months, and the car men promised that streetcars would arrive at the fair every minute and a half. The 1919 Grandstand shows included 16 hippodrome attractions: the Berlo Sisters—America's Marvelous Diving Nymphs, 20 Berber Acrobats, Chong Foo Young Duo, The Five Flying Meteors, Fantino Troup, and eleven others. A total of 75 lemonade and ice cream "hustlers" went on strike when they were told their fair contract allowed them to charge only 10¢—they were charging 15¢. Strike breakers were put on the job and "were allowed to peacefully pursue their way except in one instance where a black eye resulted." C. A. Wortham Shows provided the midway attractions, including a $15,000 Ferris wheel, and several sideshows such as "Joyland Follies musical extravaganza full of pretty girls," and "Danger—a presentation of a Chinese Opium Den demonstrating the evils of this drug habit."

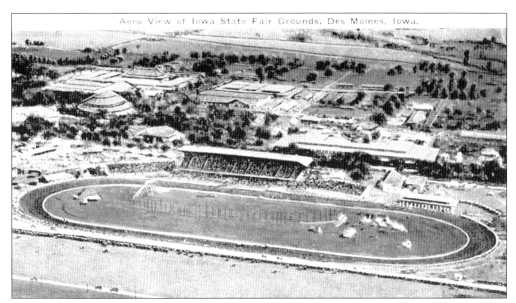

This "aero view" of the Grandstand was taken in 1926. Shows that year included Whippet dog races, appearing for the first time at the fair and Iowa native Arthur Middleton, famed baritone of the Metropolitan Opera of New York City, appearing in *The Birth of the Messiah*. Pain's Pyrotechnics nightly extravaganza *1776* commemorated 150 years of independence. It used 200 performers dressed in period costumes to recreate historic scenes and battles of the American Revolution, and used tons of fireworks.

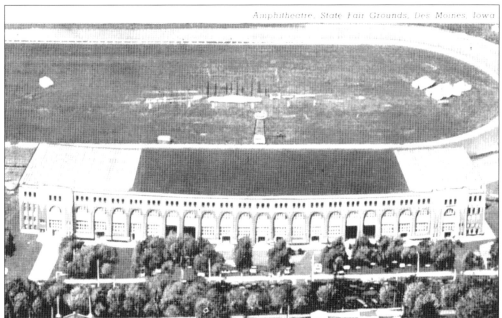

The Grandstand was renovated and enlarged in 1927 for $300,000. Five seating sections were added on the ends, adding about 5,000 seats. The ends and back of the Grandstand were enclosed with brick, and a concrete mezzanine floor installed. The rooms under the Grandstand became the Educational Building, bringing together exhibits that had been spread around the grounds. In 1927, aviator Charles Lindbergh circled the fairgrounds in his *Spirit of St. Louis*.

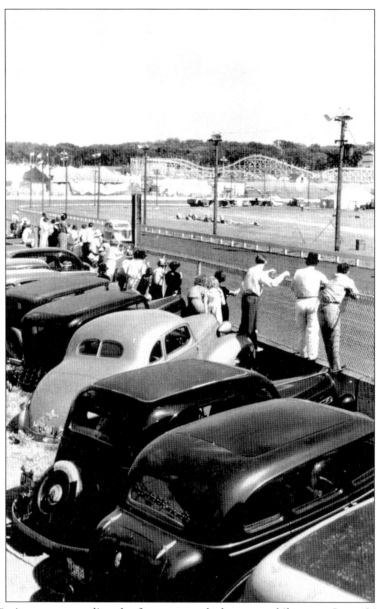

In this 1939 view, spectators line the fence to watch the automobile races. Some 24,000 people watched them on Sunday, August 27. Fair officials had promised to "scour the country" to bring in racers who could end the reign of Emory Collins of Le Mars, and Gus Schrader of Cedar Rapids. However, Collins and Schrader still won most of the races, setting records along the way against Bobby Sall, Bud Rose, Ben Shaw, Jimmy Wilburn, and others. Automobile races at the fair date back to 1901, when there were races between Fred Tone (of the Tone's Spices family) in a "Locomobile," and Rollie Fageol in the "machine he invented, a Geneva." Both were steam-powered, and their lap times convert to a blazing speed of 17 to 26 miles per hour. Tone later became the chief engineer of the American Motor Car Company in Indianapolis. Fageol and his brothers moved to Oakland, California, and started a company making trucks and buses that later evolved into Peterbilt. Famous drivers who have raced at the fair include Eddie Rickenbacker, Louis Disbrow, Ramo Stott, Ernie Derr, A. J. Foyt, Joe Merryfield, and Doug Wolfgang.

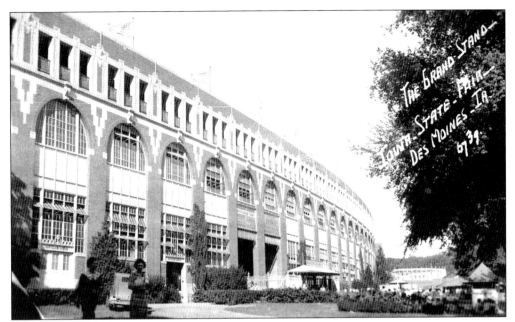

Signs over the Grandstand entrance in this 1939 view advertised automobile races, the circus, and a rodeo. Other Grandstand shows that year included Jimmie Lynch and His Death Dodgers, horse races, and a *Show of the Century* musical by Barnes and Carruthers. Novelty acts included high-wire artists the Wallendas, and Dick Granere "The World's Worst Airplane Pilot."

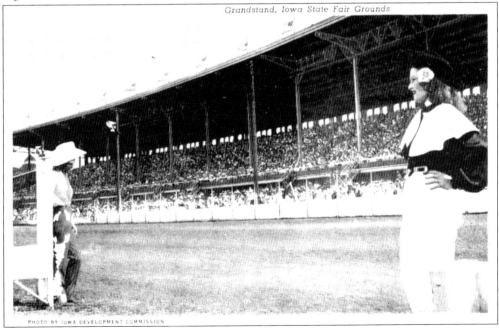

The Seventh Iowa State Fair Rodeo and Stampede was in 1939. Events included calf roping, saddle and bareback bronc riding, bulldogging, and wild horse racing. Among the cowboys taking part were "Kid" Fletcher of Hugo, Colorado, 1938 champion Brahma bull rider; "Hub" Whiteman of Clarksville, Texas, winner in the 1939 Cheyenne Wyoming and Sidney Iowa rodeos; and "Shorty" Ricker, who held the world championship in bulldogging steers from 1933 to 1938.

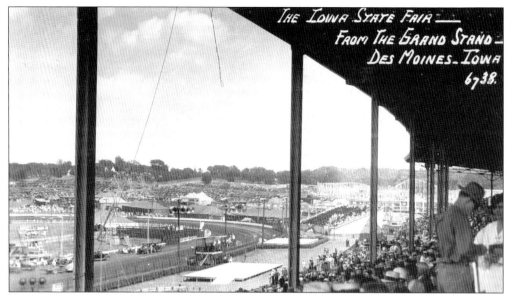

This 1940 view shows automobile races. Other shows that year included cowboy movie actor Buck Owens, who demonstrated trick riding and bullwhipping and put wonder horse Goldie through arithmetic problems. Preceding the nightly fireworks, *The Mystery Ship from Mars*, an airplane built around the Orson Welles's "Men From Mars" radio broadcast, made flights. Ben Gregory, who equipped his plane with $15,000 worth of lights and smoke-producing equipment, piloted it.

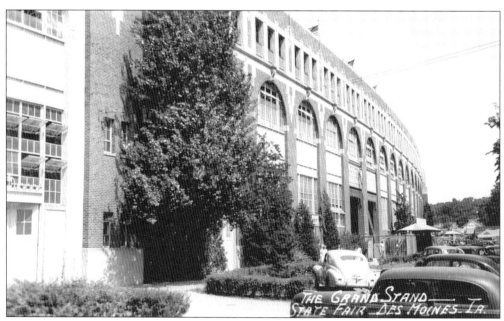

In this 1947 photograph, a man on a ladder is working on signs over the entrance reading "This Afternoon Horse Races," and "Tonight—State Fair Revue." The latter was produced by Barnes and Carruthers, a musical revue with "150 entertainers of Stage, Screen, and Radio." Most afternoon shows were either horse races or automobile races, interspersed with circus and vaudeville acts. Saturday afternoon's program was a "Thrill Show with America's Greatest Daredevils."

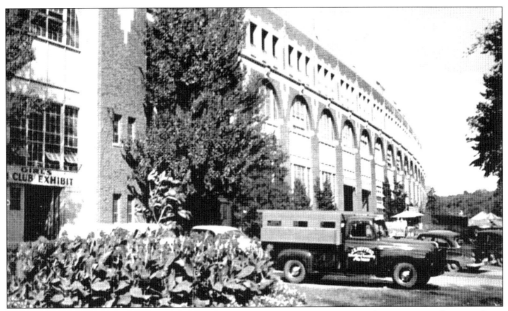

Grandstand shows in 1951, when this photograph was taken, included the Barnes and Carruthers musical production *State Fair Revue*. Automobile daredevils performed in the Thrillcade, along with escape artist Ramon LaRue who escaped from a straitjacket while hanging upside down from a helicopter 200 feet high. In the Iowa State Fair Championship Rodeo, 150 cowboys competed for $8,000 in prize money, and cowboy movie star Gene Autry made an appearance.

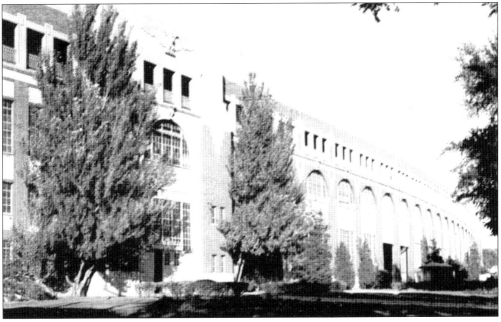

The Grandstand, shown here in 1953, again featured the big night show of Barnes and Carruthers *State Fair Revue*. Appearing in the revue were tight-wire walkers Evers and Dolores in *The Magical Wire*, and 150 others in *Come To The Fair, Autumn Time*, and *Fantasy of Mirrors*. Other Grandstand shows included automobile and horse races, the Joie Chitwood Thrill Show, and the Iowa State Fair Championship Rodeo.

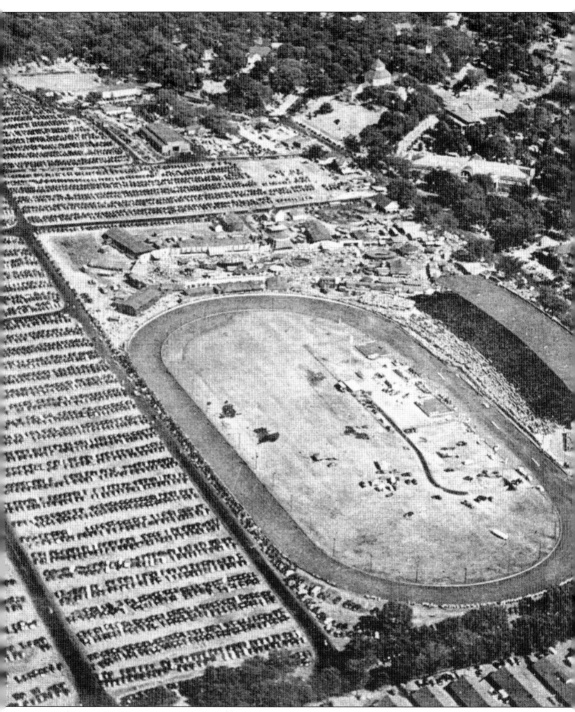

This aerial view of the fair was on a giant-size seven-by-ten-inch postcard. Postmarked on opening day, August 27, 1955, the sender wrote, "We are waiting for the races to start. Roger is sitting here making big eyes at all the girls. Oh man, there goes two good ones—see you later" signed Pete. The race that Roger and Pete were waiting to see was advertised in the program as "Jalopy Thrill Racing—Hepped up jalopies in all their battered splendor will smash and crash

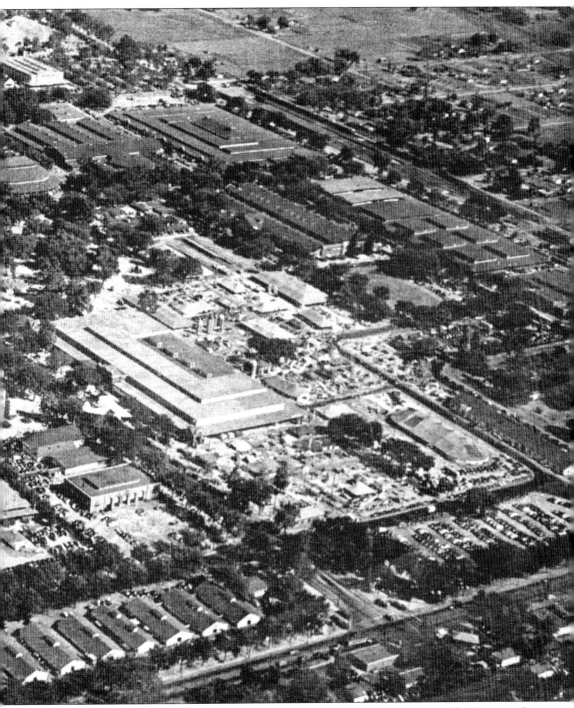

through a regular racing program" which also included vaudeville and circus acts. The Barnes and Carruthers 1955 *State Fair Revue*, with a cast of 150, performed several nights at the Grandstand. The State Fair Championship Rodeo was on Monday, September 5, the last day of the fair. It featured Gene Autry, the Cass County Boys, and Gail Davis as television's Annie Oakley.

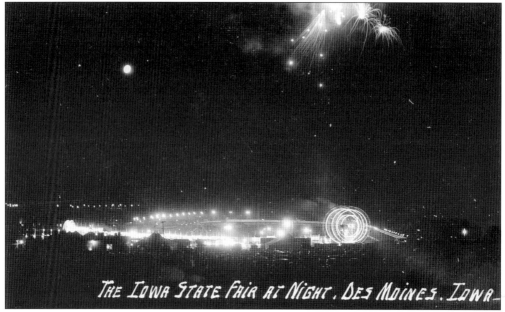

Fireworks have a long history at the fair. A 1901 news article said "fireworks were first tried last year and proved such an attraction" that they would return. The two cards shown here are from the 1940s, when fireworks concluded the Grandstand shows. In the early 1900s, fireworks did not just conclude shows, they were the whole show. They were huge "pyro-spectacular events" produced by Henry Pain's Pyrotechnics, sometimes taking 200 men to set them up, and using 300 costumed performers. His famous extravaganza, the *Last Days of Pompeii*, was performed at the fair in 1902, 1907, 1911, 1916, and 1929. Some of the other Pain shows at the fair were the *Eruption of Mt. Pelee*, *Ancient Rome*, *Opening of Panama Canal*, *The War of Nations*, *Battle of Chateau Thierry*, *Mystic China*, and *The Fall of Troy*.

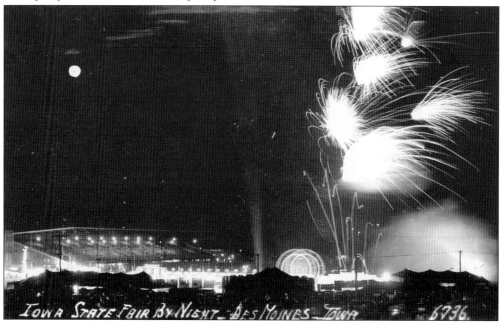

Three

AGRICULTURE AND LIVESTOCK

THE BACKBONE OF THE FAIR

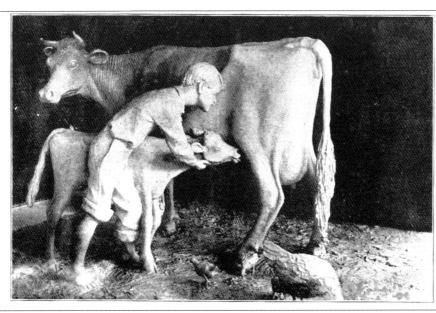

In 1911, a butter sculpture of a cow with a barefoot farmer boy helping a calf find her breakfast was exhibited by Beatrice Creamery in the Agriculture Building. It was sculpted from Pure Meadow Gold Butter by John K. Daniels, a well-known sculptor from Minnesota. Daniels was born in 1874 in Norway, and in 1884, moved with his family to St. Paul, Minnesota. Butter sculptures at the Iowa State Fair go back to at least 1907, when six-foot butter statues of United States secretary of agriculture James Wilson and Iowa governor Albert Cummins were on display in the Agriculture Building.

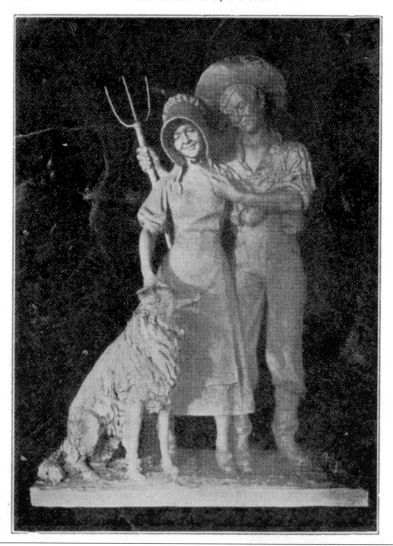
Another early butter sculpture was *The Rural Lovers*, sculpted by John K. Daniels for Beatrice Creamery. Daniels is considered by many to be one of the best sculptors Minnesota ever produced. Many of his works, sculpted from media other than butter, are in the Minnesota State Capitol and on the capitol grounds, including statues of Knute Nelson, Leif Erickson, and General Sanborn. He also sculpted monuments at several Civil War battlefield sites, and busts of William and Charles Mayo at the University of Minnesota. While in his 80s, he sculpted two huge statues, Leif Erickson in bronze and *Earthbound* in marble, for the Veteran's Administration Building on the Minnesota Capitol Grounds. He died in 1978.

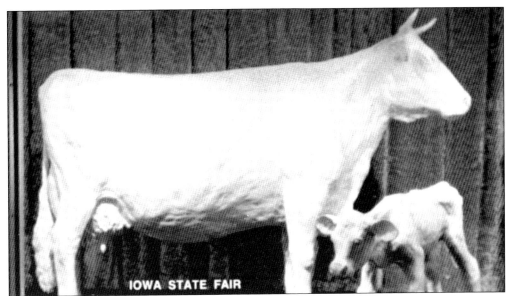

Norma "Duffy" Lyon, known as the "Butter Cow Lady," has been sculpting life-size dairy cows out of butter every year at the fair since 1960. Her butter sculptures, displayed in a 40-degree showcase in the Agriculture Building, are a major attraction drawing huge crowds every year. Her uncle, the late Phil Stong, wrote the popular novel *State Fair*. Duffy's great-grandfather, George C. Duffield, served on the Iowa State Agriculture Society from 1876 through 1887 when that organization ran the fair.

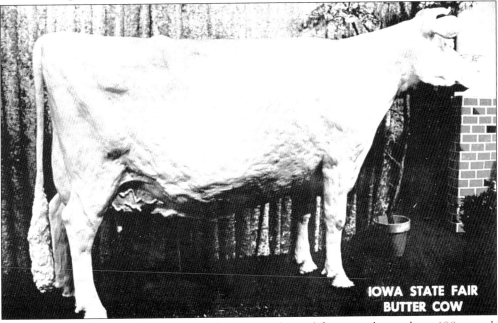

To make her butter cow, Lyon starts with a wire and wood frame, and uses about 600 pounds of low-moisture sweet Iowa butter. She started creating companion sculptures in the 1980s, including Elvis, John Wayne, a Harley-Davidson motorcycle, and her biggest project—Leonardo da Vinci's *The Last Supper*. There have been at least three butter sculptors at the fair prior to Lyon: John K. Daniels, J. E. Wallace, and Frank Dutt.

B 6- TALBOTT-ENO CO., DES MOINES

MEET US FACE TO FACE

YOU ARE INVITED

to visit our Creamery while at the

IOWA STATE FAIR

South West Ninth and Elm Streets
—just across the tracks

Refreshments served free in the rest rooms.
Leave your parcels and baggage in our care.

FARMERS CO-OPERATIVE PRODUCE CO., Des Moines, Iowa

The Farmers Co-operative Produce Company of Des Moines published this *c.* 1908 advertising postcard. "You are invited to visit our creamery while at the Iowa State Fair." The anonymous sender of this card wrote "This is a beautiful day, and I hope it will continue nice the rest of the fall. We have one or maybe two silos to fill yet. We got one and one-half filled last week. It rained so much last week we didn't get much done. I won't be sorry when we get through. How do you like this card? I have a share in this Creamery at Des Moines. I took a share 15 years ago. I have sold many a can of cream to that Creamery."

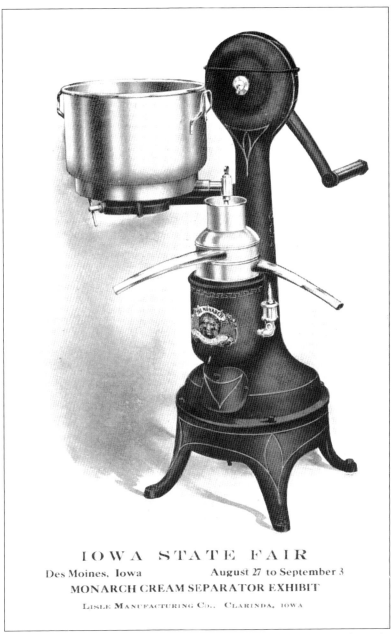

The Lisle Manufacturing Company of Clarinda published this 1909 postcard to advertise their "Monarch Cream Separator." The Lisle Factory was started in 1903, manufacturing well boring machines, and later, Monarch Cream Separators. Before mechanical cream separators were invented, the separation was made by the gravity method, allowing the cream to rise to the top of a pan and then skimming it off. C. G. de Laval of Sweden devised the first mechanical cream separator in the late 1870s, based on the principle of centrifugal force. A spindle rotates the bowl, and a series of disks separates the milk from the cream. The heavier skim milk collects on the outer side of the bowl, and the lighter cream remains in the center. The gravity method ordinarily leaves one-fourth of the fat in the milk, while the cream separator leaves only about .01 percent of the fat in the skim milk.

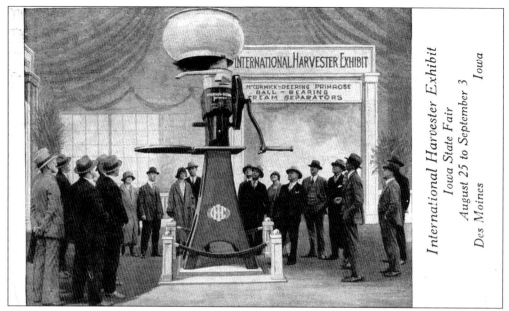

The International Harvester Company exhibit at the 1926 fair promoted their McCormick–Deering Primrose Ball Bearing Cream Separator. It was made with ball bearings to make it easier to turn. The model shown was hand-operated. They also made motor–operated models. They advertised that their separators were made in "Six Sizes—for one cow or one hundred" and claimed they "Skim Closer, Turn Easier, Last Longer!"

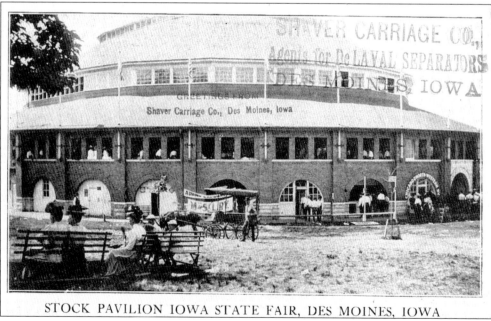

STOCK PAVILION IOWA STATE FAIR, DES MOINES, IOWA

Many early fair exhibitors gave away postcards, such as this one stamped "Shaver Carriage Co., Agents for De Laval Separators." If you believed their advertisment, De Laval was about the only brand creameries used. "Every well-known farm having its own dairy, including the royal dairies of Europe, are now users of the De Laval machines, along with 98 per cent of the creameries of the world and the great majority of the money-making dairy farmers!"

STATE FAIR

Des Moines, Ia., Aug. *1905*

My Dear ..

Arrived safe. Am having a big time—money going fast but don't worry as I have a return trip ticket, so will get home all right. Just saw exhibit of the

C. R. Harper Mfg. Company
of Marshalltown, Iowa.

They make Blacksmith Tools for farmers use and Cast Iron Soil Pipe.

Yours in haste,

IOWA STATE CAPITOL

This advertising postcard showing the Iowa State Capitol was given to fairgoers at the 1905 Iowa State Fair. The preprinted message said "Arrived safe. Am having a big time—money going fast but don't worry as I have a return trip ticket, so will get home all right. Just saw exhibit of the C. R. Harper Mfg. Company of Marshalltown Iowa. They make Blacksmith Tools for farmers use and Cast Iron Soil Pipe."

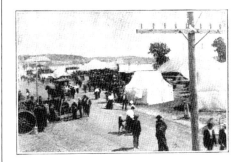
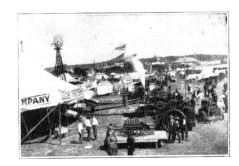

No. 93—Iowa State Fair—Machinery Exhibit.

This *c.* 1908 view shows the farm machinery exhibits. In 1908, demonstrations were given using a gasoline milking machine invented and manufactured in Council Bluffs. Steam plowing demonstrations were north of the Grand Avenue gate. Also on display were a large number of machines for elevator work on the farm and for making cement posts. Galloway of Waterloo offered a 30-day free trial of their wagon box manure spreader.

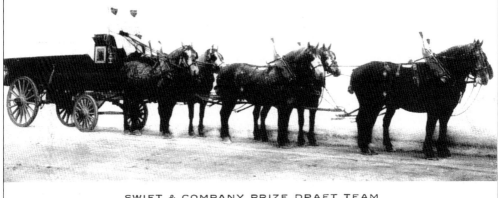

IOWA STATE FAIR, DES MOINES
AUG. 25 TO SEPT. 1, 1905

SWIFT & COMPANY PRIZE DRAFT TEAM

Swift and Company, of Kansas City, Missouri, brought their prize draft team with six matched Percherons to the Iowa State Fair in 1905. Improvements at the fair in 1905 included new surfaces for streets. It was found that cinders kept the streets in better condition than any other material, so hundreds of loads were applied. A new forage barn was built, along with an "imposing entrance" at Grand Avenue.

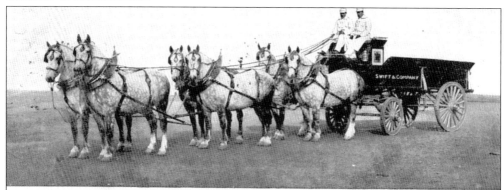

Swift & Company Prize Six-Horse Draft Team

Exhibited at

Iowa State Fair and Exposition, Des Moines, Iowa

August 27th to September 3rd, 1909

Ask your dealer for

Swift's Pride Soap and Washing Powder

The Swift and Company six-horse draft team, advertising Swift's Pride Soap and Washing Powder, returned to the fair in 1909. The wagon was built in 1899 by the Studebaker Company of South Bend, Indiana, and was used by Swift until the mid-1930s. It was then purchased by August A. Busch Jr. for Budweiser Beer. In recent years, Budweiser has used it in their east coast hitch, pulled by Clydesdales.

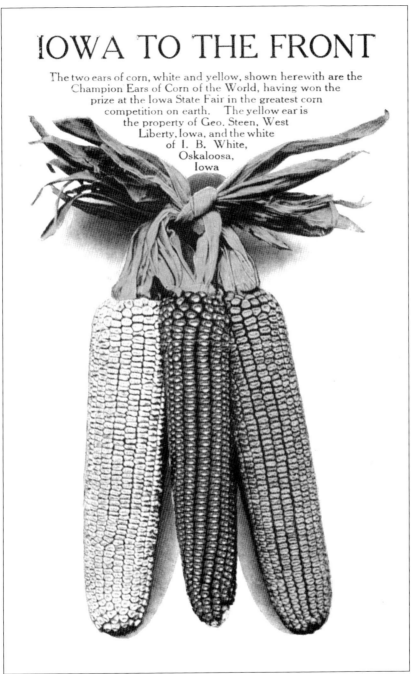

IOWA TO THE FRONT

The two ears of corn, white and yellow, shown herewith are the Champion Ears of Corn of the World, having won the prize at the Iowa State Fair in the greatest corn competition on earth. The yellow ear is the property of Geo. Steen, West Liberty, Iowa, and the white of I. B. White, Oskaloosa, Iowa

This card shows the prizewinners in corn at the 1907 fair. The card proclaimed proudly "Shown herewith are the Champion Ears of Corn of the World, having won the prize at the Iowa State Fair in the greatest corn competition on earth." The ear on the right was the property of George Steen of West Liberty, Iowa. The ear on the left was the property of T. B. White of Oskaloosa, Iowa. There was no mention about the ear in the middle. Along with judging of single ears, there was also judging for the best possible 10 ears, white and yellow, in the central district, northern district, and the southern district.

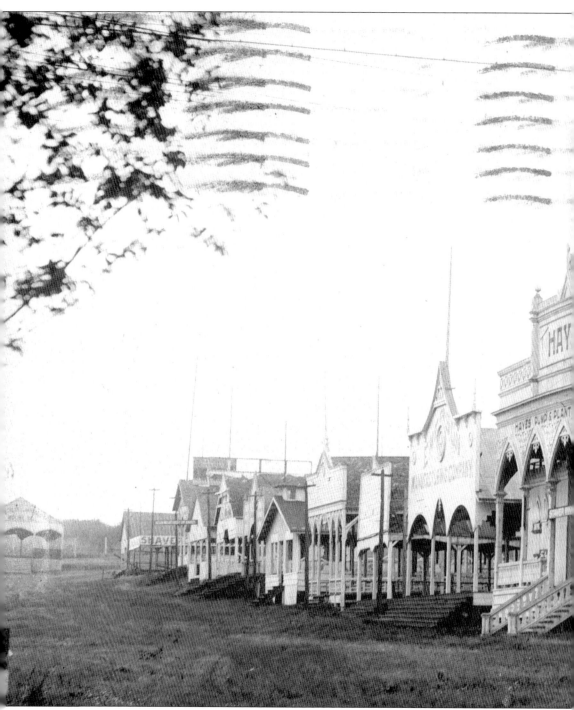

In Machinery Row, shown here on this postcard postmarked 1911, the buildings were owned by the manufacturers. This row of buildings was in "Block J", just east of where Ye Old Mill is today. The buildings that can be identified by signs are D. M. Sechler Carriage Company—Moline Illinois, Emerson Manufacturing Company—Rockford Illinois, Hayes Pump and Planter Company—Galva Illinois, and Dodd and Struthers Lightning Rods—Des

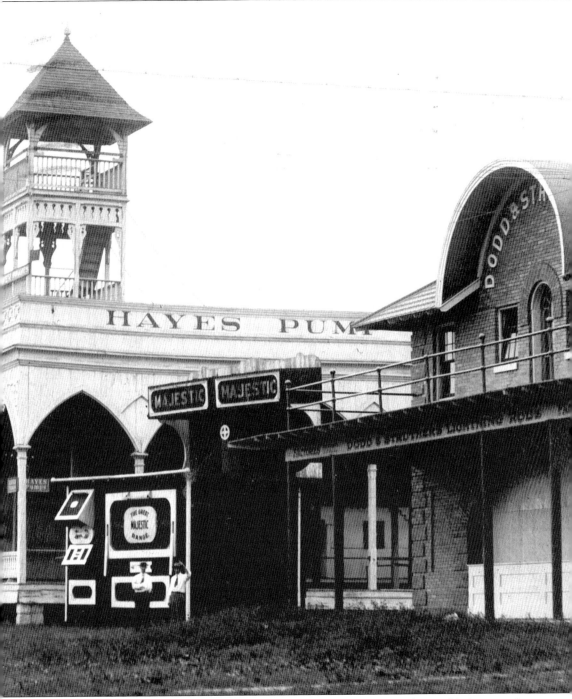

Moines. The Majestic Steel Range Company of St. Louis had a huge mock-up of their range. It was over twice as tall as the two men that can be seen standing in front. Galva Pump and Planter had a pair of Shetland ponies drawing a corn planter in operation, and a tank of ice water with miniature pumps supplying visitors with cold drinks. Other manufacturers had attractions of their own to pull in fairgoers

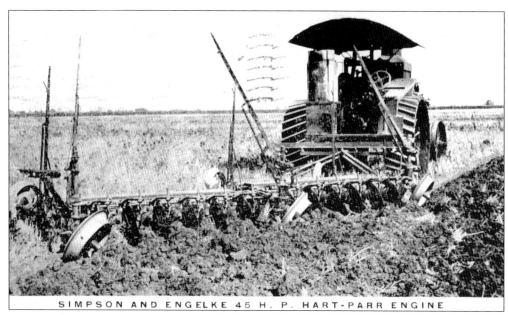

SIMPSON AND ENGELKE 45 H. P. HART-PARR ENGINE

In 1911, the Hart-Parr Company of Charles City, Iowa, gave plowing demonstrations in the machinery area southwest of Machinery Hall (Varied Industries Building). This advertising card shows a Simpson and Engelke 45 horsepower Hart-Parr Engine (using a low grade of kerosene) on a tractor plowing 30 acres per day at California Junction, Iowa.

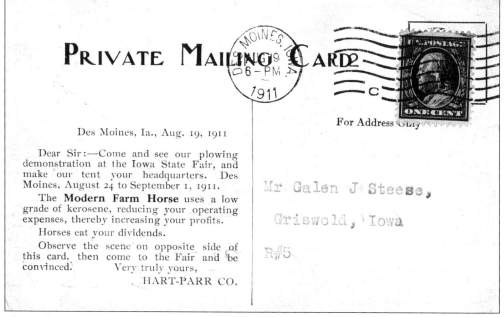

Their advertising message, on the back of the above card, was mailed to farmers on August 19, 1911, inviting them to "Come and see our plowing demonstration at the Iowa State Fair." They advertised the tractor as a "Modern Farm Horse" and added "Horses eat your dividends." They said to "observe the scene on the opposite side of this card, then come to the Fair and be convinced."

In 1914, Galloway and Company from Waterloo had the largest machinery exhibit at the fair. Second largest was the International Harvester Company. The Machinery Hall was full, and other machinery exhibits and tents were spread out over 20 acres at the West End of the fairgrounds, a portion of which is shown here. Early predictions were that manufacturers would take orders for at least $3 million worth of machinery that year.

In this early view of machinery exhibits at the fair, a "Port Huron" sign is visible on top of one of the tents, belonging to the Port Huron Engine and Thresher Company of Port Huron, Michigan. In the foreground is a tent with a large sign reading "Little Giant Tractor and Taylor Corn Pickers for sale by American Tractor Co., Des Moines." Several silos can be seen in the background.

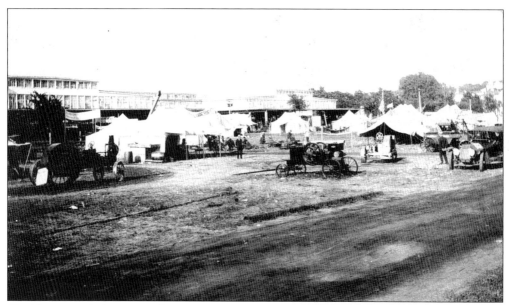

World War I ended in November 1918, which helped the machinery show at the 1919 Iowa State Fair to be one of the largest in the country, tied in size with the Minnesota State Fair. There were 196 tractors of all makes being shown in sizes ranging from 40 to 80 horsepower down to 5 to 10 horsepower. The silo and ensilage cutter exhibit was the largest in the United States.

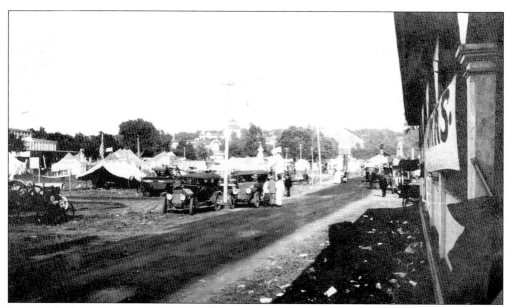

In 1919, C. H. Turk, superintendent of farm implements and machinery, said that when he took over that department 22 years before, the machinery exhibits occupied only two small blocks in the northeast part of the fairgrounds. In 1919, the era of this postcard, all the ground west of the Administration Building was for exhibits of machinery and farm implements.

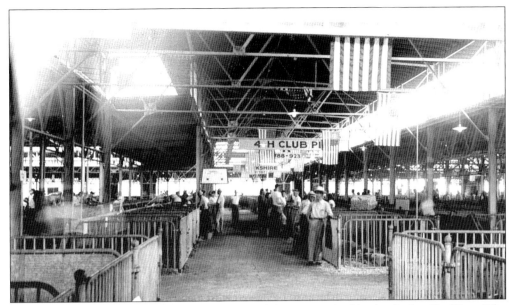

This view in the late 1940s shows the 4-H Club pig area inside the Swine Pavilion. The superintendent of the Swine Department was E. T. Davis of Iowa City—the director of the first district. The supervisor of exhibits, and one of the judges, was E. L. Quaife of Ames. Classes judged included Poland Chinas, Durocs, Chester Whites, Hampshires, Berkshires, Herefords (a minor breed of pigs), and market pigs.

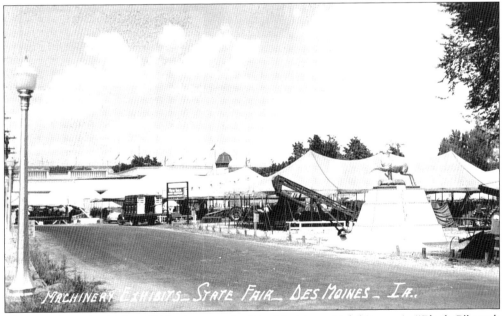

The area shown in this late 1940s photograph of the Machinery Exhibits was in "Block C" south of the Varied Industries Building. Exhibitors in this block included John Deere Plow Company of Moline, Illinois; New Idea Farm Equipment of Sandwich, Illinois; J. I. Case Farm Machinery of Des Moines; Superior Separator Company of Hopkins, Minnesota; Berry Brothers Farm Equipment of Des Moines; and Twin Draulic Company of Laurens, Iowa.

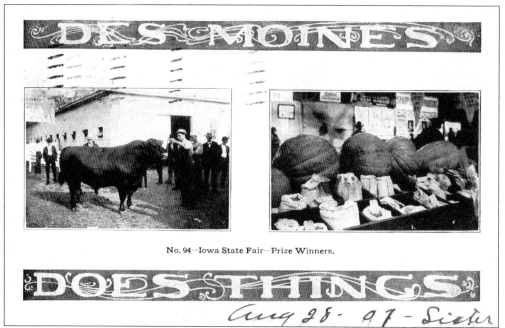

No. 94—Iowa State Fair—Prize Winners.

Aug 28 - 97 - Sister

Favorites of fairgoers over the years are the giant vegetables and fruits on display in the Agriculture Building. The giant pumpkins shown in this *c.* 1907 postcard are small in comparison to giant pumpkins grown today. In 2004, the state fair record of 500.5 pounds was broken when a giant pumpkin (really a squash) tipped the scales at 871.9 pounds!

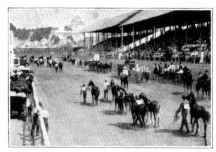

No. 95—Iowa State Fair—Parade of Prize Winners.

A long-standing tradition at the end of early Iowa State Fairs was the "Parade of Champions," sometimes called the "Million Dollar Parade" or the "Parade of Prize Winners." All of the cattle and horses that won premiums during the fair (sometimes estimated to be as many as 500 each) were paraded around the racetrack before the Grandstand. Fair officials and livestock superintendents would ride at the head of the parade.

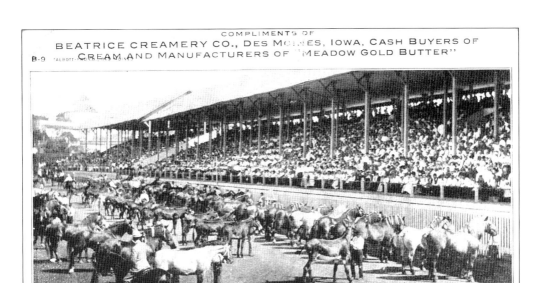

Beatrice Creamery of Des Moines published several complimentary postcards of the fair, including this *c.* 1908 photograph of prize-winning horses in the Parade of Champions at the Grandstand. Beatrice Creamery, "cash buyers of cream and manufacturers of Meadow Gold Butter," sponsored the butter cows (and other figures) sculpted from "pure Meadow Gold Butter" that were displayed in the Agriculture Building in the early 1900s.

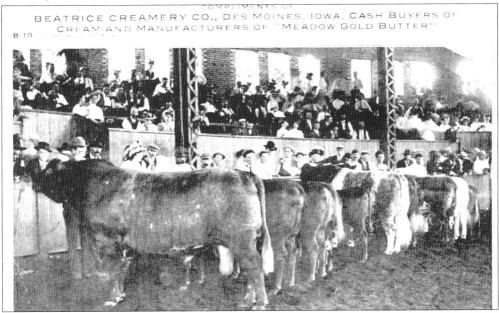

This Beatrice postcard shows cattle judging in the Livestock Pavilion around 1908. George Haskell and William Bosworth founded Beatrice Creamery in Beatrice, Nebraska, in the 1890s. In 1905, the company was incorporated as the Beatrice Creamery Company of Iowa, and was joined by the Meadow Gold brand of dairy products. By the 1930s, its 32 plants produced 27 million gallons of milk and 9.5 million gallons of ice cream per year.

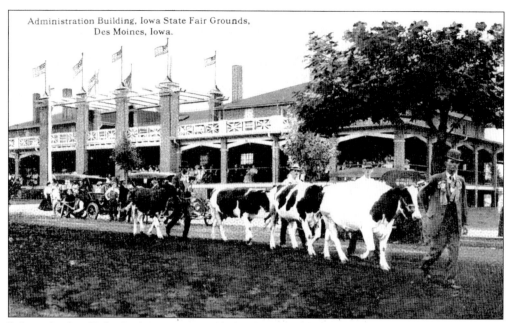

Administration Building, Iowa State Fair Grounds,
Des Moines, Iowa.

Prize-winning Holstein dairy cows parade by the Administration Building, led by their proud exhibitors who are sporting the cow's winning ribbons on their chest. They are on their way to the Parade of Champions at the Grandstand. Interested fairgoers watch from the shade on the porch and from automobiles parked alongside on the street, in this *c.* 1910 postcard.

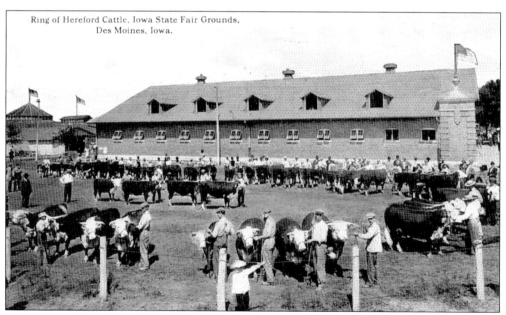

Ring of Hereford Cattle, Iowa State Fair Grounds,
Des Moines, Iowa.

Hereford Cattle, shown here in 1912, were judged by Frank Van Natta from LaFayette, Indiana. The senior and grand champion bull was Fairfax 16th, shown by J. P. Cudahy from Belton Missouri; the junior champion bull was Repeater 7th, shown by O. Harris; the senior and grand champion cow was Scottish Lassie, shown by J. P. Cudahy; and the junior champion cow, Miss Repeater 11th, was shown by O. Harris.

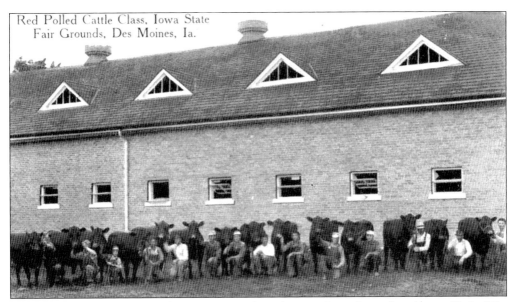

Red Polled Cattle Class, Iowa State Fair Grounds, Des Moines, Ia.

Red Polled Cattle are shown here in 1912, when the superintendent of cattle was H. L. Pike from Whiting. The judge was J. W. Wilson from Brookings South Dakota. The senior and grand champion bull was Teddy's Best, shown by Haussler Brothers from Holbrook, Nebraska; the junior champion bull was Paul, shown by Frank Clouss from Barnum; the senior and grand champion cow was Lena, shown by Frank Clouss; and the junior champion cow was Ida Loo, shown by Charles Graff from Bancroft, Nebraska.

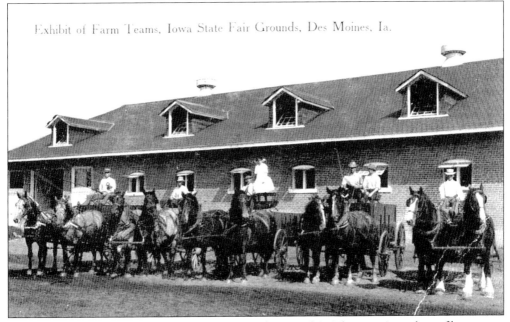

Exhibit of Farm Teams, Iowa State Fair Grounds, Des Moines, Ia.

Farm teams at the Horse Barn are shown here at the 1912 fair. The superintendent of horses was Charles F. Curtiss from Ames. The judge was R. B. Ogilvie from Chicago. First place went to Frank E. Huston from Waukee, second place to R. F. French from Independence, third place to G. W. Grigsby from Madrid, Fourth place to G. E. Cole from Fonda, and fifth place to C. B. Dannen and Sons from Melbourne.

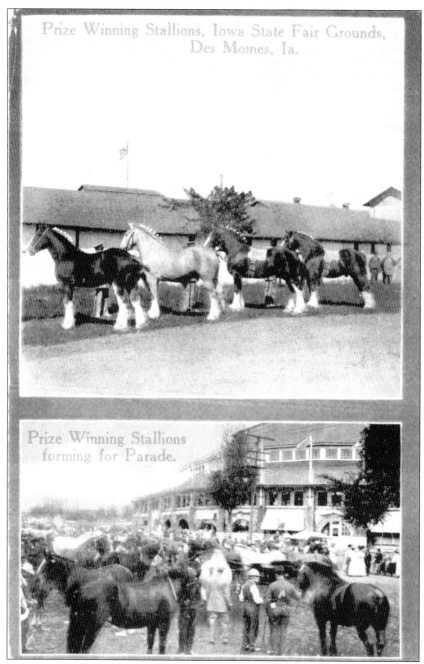

Prize Winning Stallions, Iowa State Fair Grounds, Des Moines, Ia.

Prize Winning Stallions forming for Parade.

The prize winning stallions at the 1912 Iowa State Fair are shown here. The superintendent of horses was Charles F. Curtiss of Ames. Draft horse classes judged were Percherons, Clydesdales, English Shire, and Belgians. The Percherons, judged by Wm. Bell, attracted the most attention. Incruste was the champion stallion, owned by H. G. McMillan and Sons of Rock Rapids. Wm. McKirdy judged the Clydesdales. Charnock was the champion stallion, owned by Galbraith and Son of DeKalb, Illinois. R. B. Ogilvie judged the Shires. Lord Carlton was the champion stallion, owned by Truman's Stud Farm of Bushnell, Illinois. Alex Galbraith judged the Belgians. Villiant De Merfes was the champion stallion, owned by George Eggert of Newton.

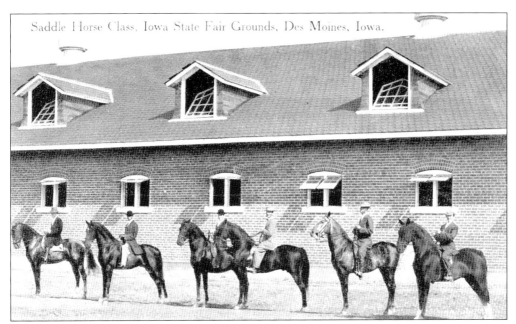

Saddle Horse Class, Iowa State Fair Grounds, Des Moines, Iowa.

This view shows saddle horses at the 1912 fair. Walter Palmer from Ottawa, Illinois, was the judge. Iowa exhibitors of saddle horses included W. and A. Graham from Des Moines, Hamilton Brothers from Keota, Hillcrest Farm from Ottumwa, C. E. Monahan from Des Moines, H. H. Polk from Des Moines, R. L. Porter from Des Moines, Bruce Robinson from Washington, Mrs. Adam Stirling from Des Moines, and Fred Williams from Barnes City.

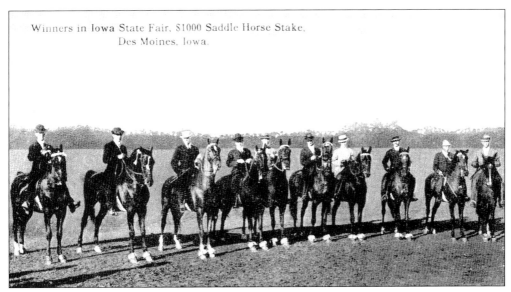

Winners in Iowa State Fair, $1000 Saddle Horse Stake, Des Moines, Iowa.

The winners in the Five Gaited $1,000 Saddle Horse Stake are shown here. The year 1914 was the first time this event was held at the Grandstand. Judge Porter Taylor awarded first place to Astral King, owned by James Houchin; second place to Kentucky's Best, owned by Lula Long; third place to Johnnie Jones, owned by Paul Brown; fourth place to Maurine Fisher, owned by Lula Long; fifth place to Miss Cliff, owned by the University of Minnesota; sixth place to Majestic McDonald, owned by Ed Moore; and seventh place to Art Bonta, owned by Hamilton Brothers.

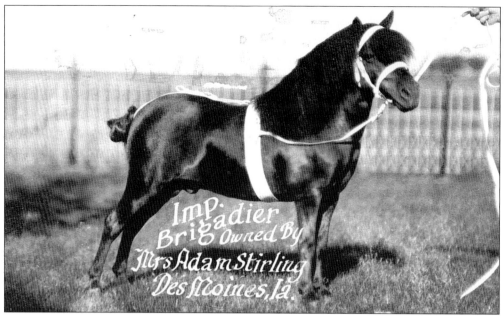

Mrs. Adam Stirling of Des Moines was the owner of Imp. Brigadier, a Shetland pony. Stirling was a Shetland exhibitor at the Iowa State Fair in the early 1900s. She evidently was so proud of this pony that she had a photograph of it made into a postcard. In 1910, there was a record of 160 ponies entered in breeding, harness, and saddle classes, judged by professor W. J. Kennedy from Ames.

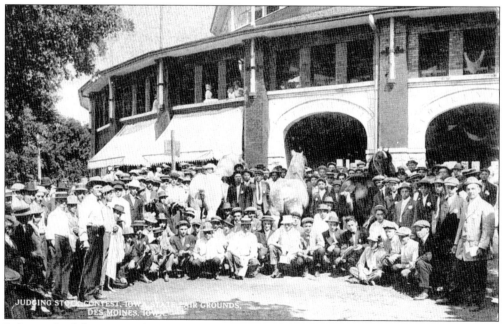

Judges and exhibitors pose for a group photograph in front of the Livestock Pavilion around 1912. An article about the Iowa State Fair in the September 4, 1912, issue of *The Breeder's Gazette*, a weekly magazine published in Chicago, reported that "the judging for the most part presented the conclusions of trained men and was largely accepted without murmur by exhibitors."

Four

THOSE GRAND
OLD FAIR BUILDINGS

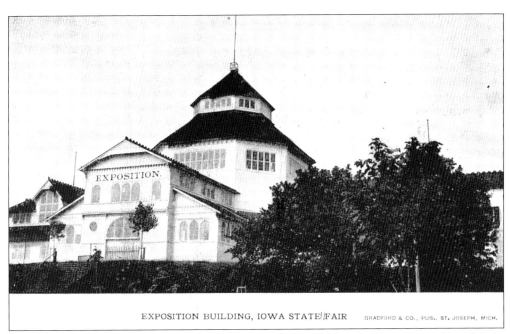

EXPOSITION BUILDING, IOWA STATE FAIR BRADFORD & CO., PUB., ST. JOSEPH, MICH.

The grandest of the Iowa State Fair buildings was the Exposition Building. It was built for the 1886 fair; the first fair at its present location in Des Moines. It was used for exhibits that are now in the Varied Industries Building and elsewhere on the grounds. The textile department was there, with exhibits and ribbon-winners in quilts, afghans, knitting, and embroidery. Davidsons, Younkers, and other stores exhibited there. Salesmen hawked their wares for the latest wonderful invention or kitchen gadget, from potato peelers to mechanical carpet sweepers.

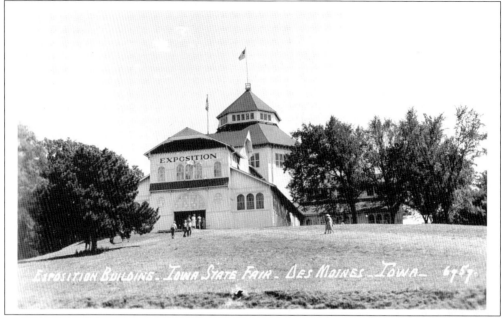

The year 1949 was the final fair for the Exposition Building. The fire marshal said its frame construction and age made it a fire hazard. In early 1950, fair secretary L. B. Cunningham gave the order to demolish it. The site where it was located still bears its name, Exposition Hill, and is used today for bungee jumping.

Pioneer Hall is the last building remaining today from the 1886 fair. An imposing wooden building with its distinctive cupola, it is shown here in the early 1900s. It was originally the Agriculture Building, then the Poultry Building. In 1938, it became an employee dormitory, and later a storage building. In 1965, it became Pioneer Hall, housing the Iowa Museum of Agriculture, and events such as fiddlers' contests. (Courtesy State Historical Society of Iowa.)

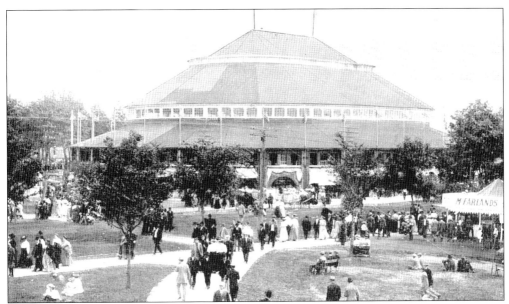

The 47,000-square-foot Livestock Pavilion, with its distinctive three-tiered roof, was built in 1902, the first masonry building constructed at the fair. Oliver Smith, the architect of the Administration Building, Amphitheater, Horticulture Building, Machinery Hall, Swine Pavilion, and horse and cattle barns, designed it. It seats about 2,000, and is where livestock judging and evening horse shows take place. The original wooden seats and under structure were replaced in 1989.

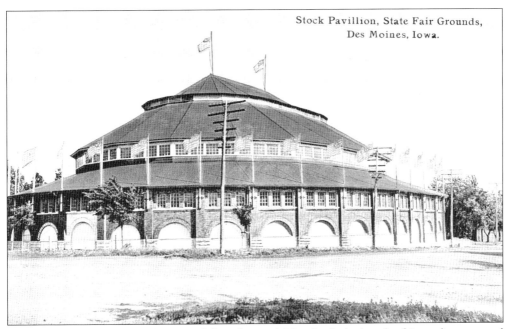

The Livestock Pavilion has been used for other activities, both during the fair, and year round during the off-season. Some of the events were motorcycle races, boxing matches, circuses, and sales conventions. In the 1930s, when walkathons and dance marathons were the rage, they were held in the Livestock Pavilion. The 1933 State Fair Report listed walkathon receipts of $26,193.23.

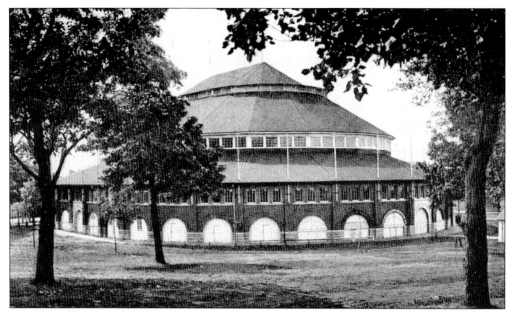

In the early 1900s, circus and vaudeville acts sometimes appeared at the Livestock Pavilion in between livestock competitions. In 1911 and 1912, some of the acts included Mooney's Electric Tandem (horses and carriage decorated with lights), Leon Morris's Comedy Ponies, D'Balestrier's Trained Bears, Alfred the Great Man Monkey, and a push ball contest between "cowboys and Indians." In 1911, Ezra Meeker of Old Oregon Trail fame appeared in the pavilion.

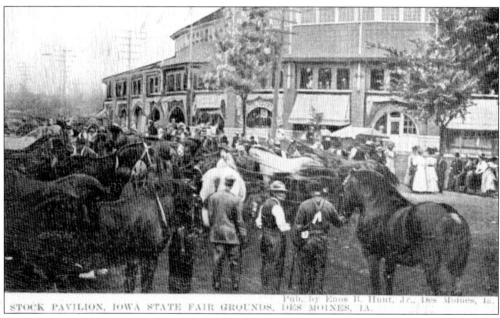

Horses in this *c.* 1910 postcard congest the street outside of the Livestock Pavilion. It could be worse! The September 4, 1912, issue of *The Breeder's Gazette*, reporting about the Iowa State Fair, said "horses occupied the Coliseum arena in the morning, and cattle in the afternoon, so that the dangerously congested condition witnessed in the arenas of other state fairs, when both cattle and horses are in the arena simultaneously, was absent."

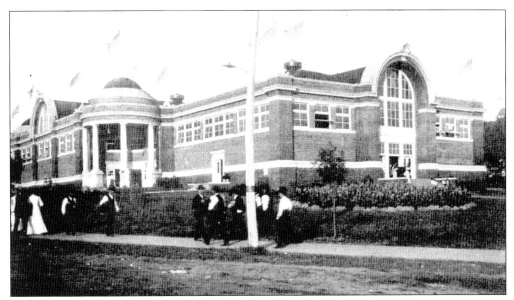

The Agriculture Building was constructed in 1904 of red brick and stone, with two Jeffersonian domed rotundas. It is one of the best examples left in the world of exposition-style architecture. One of Pain's Pyrotechnics fireworks displays at the Grandstand that year was a picture of the new Agriculture Building in fire. When it opened in 1904, the floor was still dirt. The concrete floor was laid at a later date.

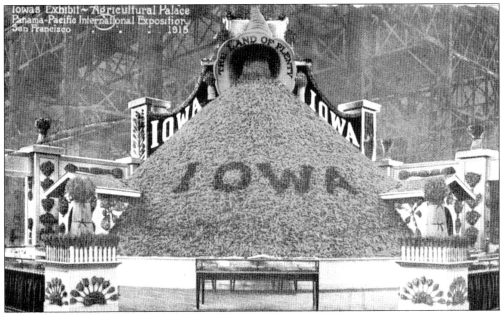

An exact replica of the Iowa Horn of Plenty, shown here at the 1915 Panama Pacific International Exposition in San Francisco, was displayed in the Agriculture Building in 1916. It was made from agricultural products grown in Iowa. It was 65 feet wide at the base, and 45 feet high. It was said to be one of the more popular exhibits at the 1916 Iowa State Fair.

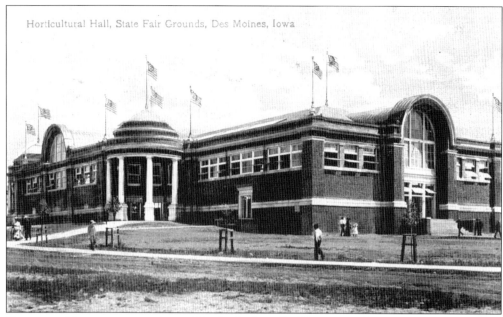

Horticultural Hall, State Fair Grounds, Des Moines, Iowa

Shown on this page are two views of the Agriculture Building around 1908. In 1938, the Works Progress Administration (WPA) commissioned artists Dan Rhodes and Howard Johnson to paint a 110-foot-long by 10-foot-high mural in the Agriculture Building. *The History of Agriculture* depicted the pioneers driving away the Native Americans, plowing their fields, and building their houses. After complaints about its portrayal of farmers and other inaccuracies, fair secretary Lloyd Cunningham sought approval from the fair board to have it destroyed. Cunningham said "The mural wasn't art, it was WPA. It was an insult to Iowa farmers because it depicted them as club-footed, coconut-headed, barrel-necked and low-browed." In 1946, the mural was destroyed and the lumber used to make repairs around the fairgrounds. Paul Backensten rescued one piece of the mural, 10 feet long by 5 feet high. Its whereabouts today is unknown.

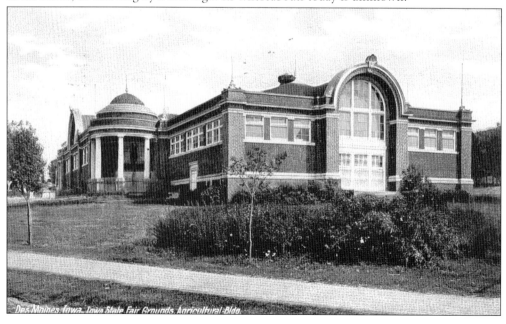

Des Moines, Iowa. Iowa State Fair Grounds, Agricultural Bldg.

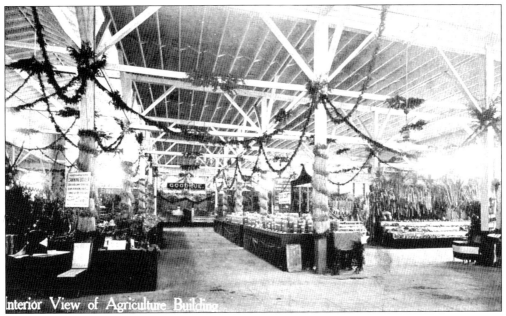

This interior view of the Agriculture Building was taken around 1910. In 1910, fair secretary J. C. Simpson eliminated county exhibits in the Agriculture Building, and substituted individual farm exhibits. There were 21 entries in three classes: farms 80 acres or less, farms more than 80 acres, and farms from Polk County. Over $1,200 was offered in prizes. Entries were judged on quality and variety of products from field, garden, and orchard.

An exhibit sign in this *c.* 1910 postcard of the Agriculture Building reads "Ginseng & Golden Seal." Around this time, there was a ginseng craze, and some farmers thought they could get rich quick. It was said that ginseng could be easily grown from seeds costing a few cents each, required little attention, and sold for $8 a pound. However, diseases soon appeared, the plants rotted away, and the craze came to an end.

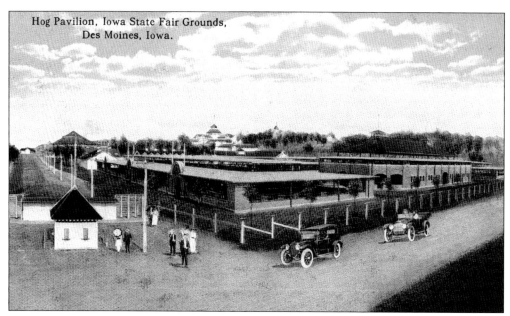

Hog Pavilion, Iowa State Fair Grounds, Des Moines, Iowa.

The Hog Pavilion was built in 1907 at a cost of $80,000. Fair advertisements said to "See the Iowa hog in a Palace." In 1926, the first statewide Hog-Calling Contest was held in the pavilion, with $50 in prizes. Fair secretary A. R. Corey said (tongue-in-cheek) that nervous breakdowns threaten the hogs, and that "panic by the hogs is extremely likely with the meal summons coming at frequent intervals without the presumed food."

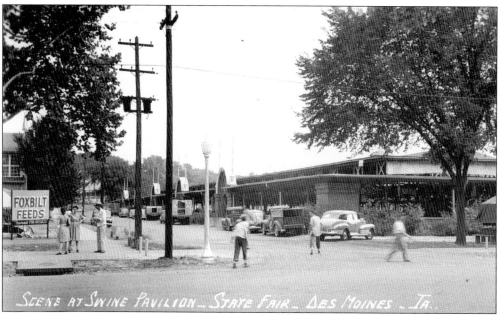

A large sign, "Foxbilt Feeds," is on the left side of this 1940s photograph of the Swine Pavilion. Foxbilt Feeds, owned by Ed Fox of Des Moines, was a frequent exhibitor and concessionaire at the fair in the 1930s through the 1950s. They manufactured poultry feed concentrate to mix with grain called "Poultrate." Their advertising slogan was "What is it costing you to produce one dozen eggs?"

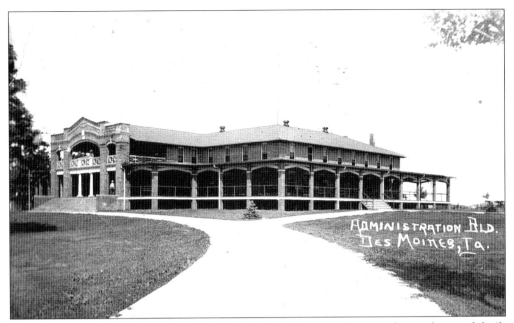

The Administration Building was constructed of red bricks in 1908. Its wide wooden porch built around all four sides has always been a popular place for fairgoers to rest and "people watch." It has undergone renovations in recent years, along with a completely new interior. The original fountain from the "big resting room in the middle" still stands in the main lobby.

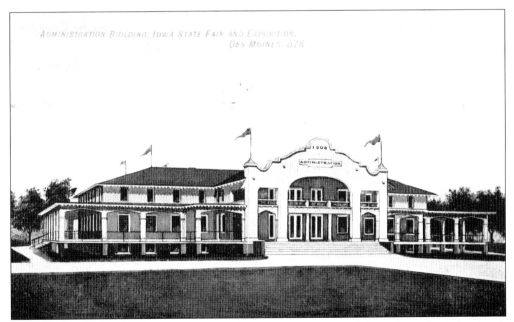

On August 19, 1908, before the fair opened, a newspaper reported that a "gang" tried to break into the Administration Building. Three suspicious looking men entered the fairgrounds at 11:00 p.m., and at midnight were seen creeping toward the Administration Building. Two fairground officers hid under the porch, and when the men approached the windows and front door, the "officers came out with guns drawn and captured two." The third man escaped.

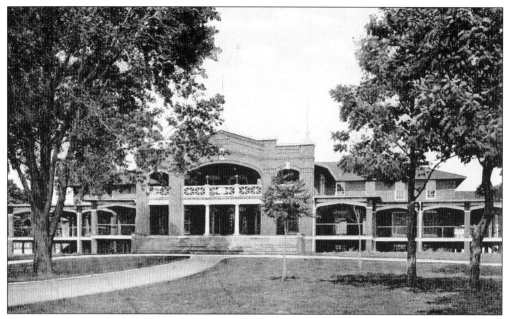

One night during the 1909 Iowa State Fair, all of the electric lights went out in the fairgrounds for a couple of hours leaving the treasurer's offices in the Administration Building in "utter darkness." A newspaper reported that "As soon as the power went down, candles were secured for the treasurer's office where thousands of dollars were stacked on the counters. Big ugly revolvers were brought out and laid at the side of each candle."

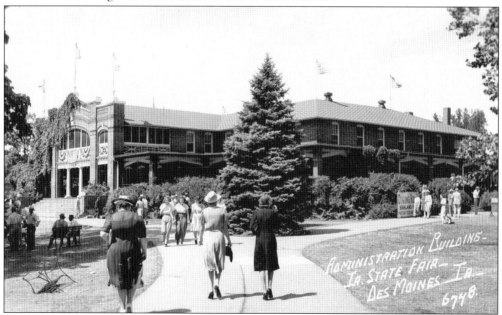

A sign on the east side of the Administration Building in this 1940s photograph reads "Dining Room—Highland Park Presbyterian Church." When the fair was closed from 1942 to 1945, during World War II, the Army used the fairgrounds for storage and a supply depot for the C-54 four-engine transport plane. The main offices of the Army were in the Administration Building, and the top-secret Norden Bombsight was stored there and kept under constant guard.

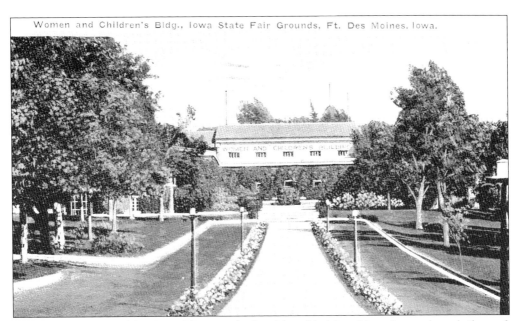

Women and Children's Bldg., Iowa State Fair Grounds, Ft. Des Moines, Iowa.

The Women and Children's Building was built with red brick, white trim, and a red tile roof. Designed by architect Oliver Smith, it cost $75,000 to build, and was dedicated at the 1914 Iowa State Fair. The porch provided a nice view overlooking the fairgrounds. The outside walls became covered with grapevines, and the wide walkway on the west side leading up to it was lined with hydrangeas.

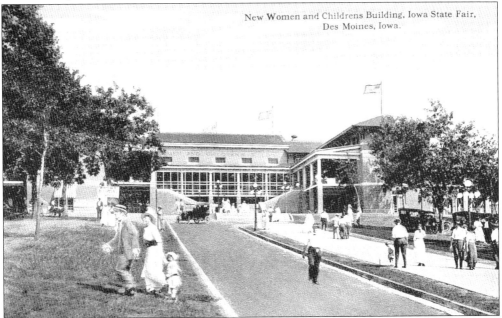

New Women and Childrens Building, Iowa State Fair, Des Moines, Iowa.

The Women and Children's Building had a 700-seat auditorium. "Domestic Science" programs were held there dealing with home furnishing, nutrition, and child development. The Iowa Federation of Women's Clubs, the Iowa Farm Bureau Women's Committee, and the Iowa Congress of Parents and Teachers (PTA) sponsored many of the programs. Younkers and other clothing stores presented clothing and style shows in the auditorium.

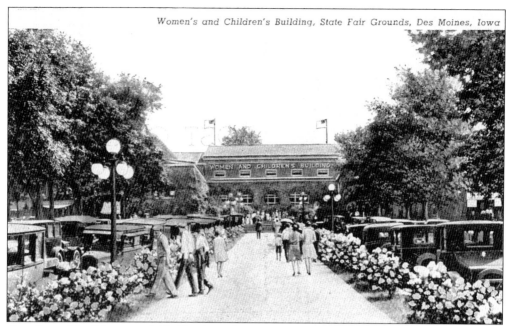

One floor of the Women and Children's Building was for rest and relaxation of women, children, and "old folks." There were plays, puppet shows, and musical presentations in the auditorium. Dance recitals were presented over the years with pupils from local dance studios directed by Caroline Putnam Crawford, Marie Barnes Flanagan, Sylpha Snook, and others.

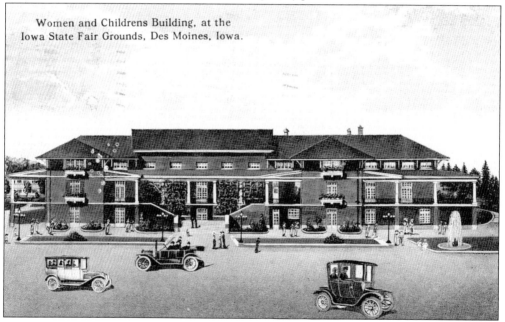

One of the more popular programs at the fair was the baby health contest, judged by doctors and nurses using scorecards. It was first held in 1911 at the College Building. After the Women and Children's Building was built, it moved there. By the 1920s, it became so popular that it had to be limited to 700 entries. It was cancelled in 1949 due to the polio epidemic, and the last contest was in 1951.

In 1951 and 1952, the *Hey Bob Show*, a popular Des Moines children's radio program on KRNT that dealt with safety, originated from the Women and Children's Building. Using a full sized "Hey Bob" dummy, the show was created by Bob Hassett of Des Moines, and emceed by Bill Riley. Riley would say, "What do you yell when you see a traffic violation?" and the kids would respond "Hey Bob!"

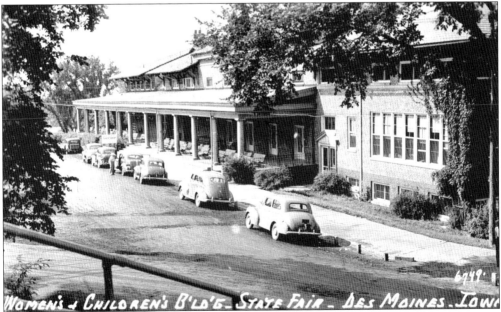

In 1951, WOI-TV started broadcasting the fair activities from studios in the Women's and Children's Building. In its later years, the building became the Cultural Center. Grant Wood, Iowa's famous artist, displayed some of his paintings there. Sadly, the building began to deteriorate due to a leaky roof, and was deemed to be too costly to repair. It was torn down after the 1980 fair, and the site became an open-air stage.

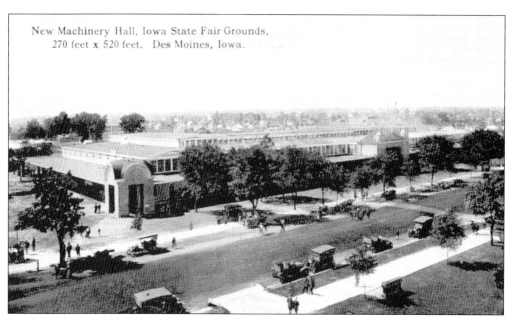

New Machinery Hall, Iowa State Fair Grounds, 270 feet x 520 feet. Des Moines, Iowa.

The Machinery Hall, 270 feet by 520 feet in area, was built of steel and concrete in 1911 for a cost of $75,000. In the early 1930s, it was renamed the Varied Industries Building. In 2001, it was upgraded and renovated into a year-round facility with heating and air conditioning, and renamed the William C. Knapp Varied Industries Building, due to Knapp's contribution that started the renovation.

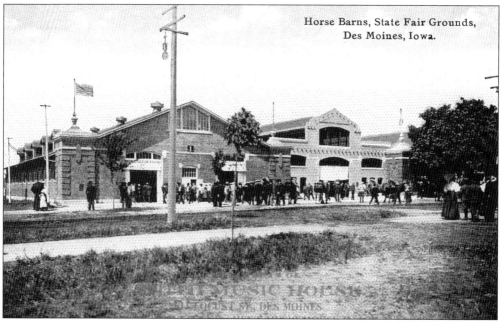

Horse Barns, State Fair Grounds, Des Moines, Iowa.

Oliver Smith, the architect of many early fair buildings, designed the horse barns in 1907. There were additions in 1909, 1912, 1929, and renovations in 1999. The addition in 1912 was brick and steel, and added stalls for 130 draft horses, 132 ponies, and a 60 foot by 132 foot carriage section. It now has 12 aisles, with 398 box stalls and 53 ties, covering two acres.

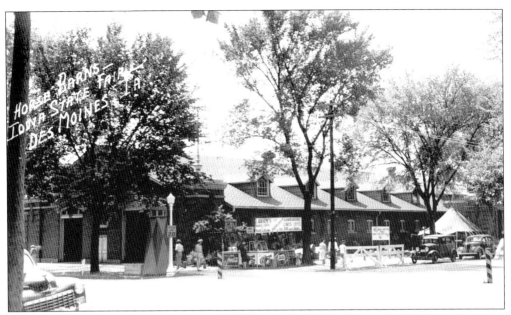

Prior to 1937, when a new Maintenance Building was built, the front end of the horse barn was used as a mechanics shop. A large canvas tarp closed off the area, and a coal furnace was used for heating. In 1929, when the elephant baby, Mine, first came to the fair, she was kept in the horse barn. She was moved in 1937 to the new Maintenance Building.

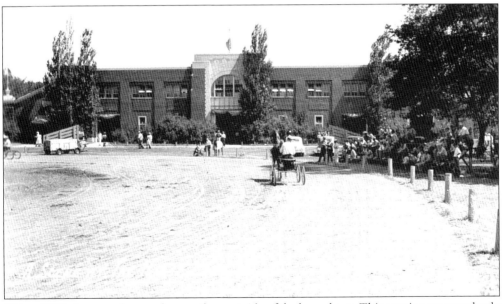

This *c.* 1940 photograph was taken on the west side of the horse barn. This area is now completely covered with a roof, and is called the West Arena. It provides 29,000 square feet for various fair activities such as horse shows, team horse-pulling contests, sheep dog trials, and other activities. It is also used off-season for horse shows and other events.

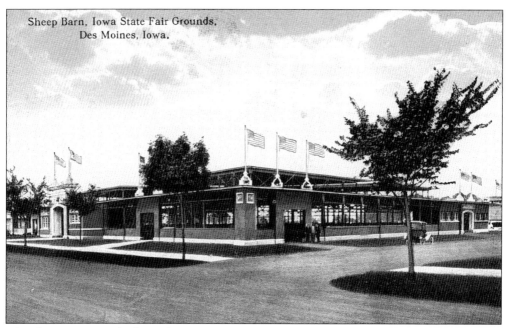

The Sheep Barn was built in phases: 1915, 1923, and 1939. There are terra-cotta sculptures of ram heads around the outside. It now covers six acres, has 370 sheep pens, and a show ring with bleachers to seat 500. The west half of the building has 1,100 cattle ties, and is used as the Youth Cattle Barn. During World War II, four-motored airplane wings were stored here

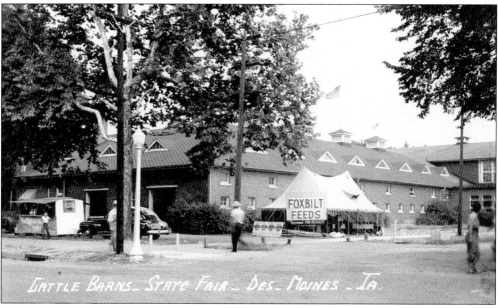

Architect Oliver Smith was once again hired to design the brick Cattle Barn. Started in 1914 and completed in 1920, the concrete-floored building covers 154,000 square feet, and has stalls for 1,600 head. In 1997, the sale ring was renamed the Penningroth Media Center after longtime livestock exhibitors Don and Orville Penningroth who bequeathed a donation from their estate. Events in the center today include the Sale of Champions, Youth Spelling Bee, and Monster Arm Wrestling.

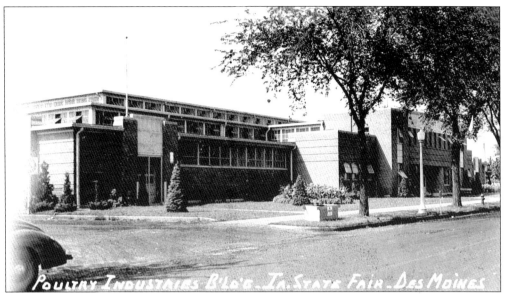

The Poultry Building was built in 1937 at a cost of $130,000. The dedication in 1938 was broadcast on KSO and WHO radio with Herb Plambeck and fair secretary A. R. Corey. The old poultry building (now called Pioneer Hall) was converted to a dormitory for fair employees. Poultry entries increased from 2,500 in 1937, to more than 6,000 in 1938.

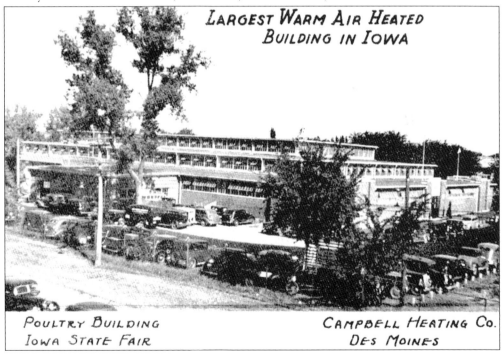

The publicity about the new Poultry Building generated so much interest that several hundred birds had to be put in a tent adjoining it. After the Des Moines Coliseum burned in 1949, demand increased for conventions and trade shows, thus many of them were held in the Poultry Building. In 1965, it became the 4-H Exhibits Building. Off-season uses include automobile shows, home and garden shows, sports shows, and flea markets.

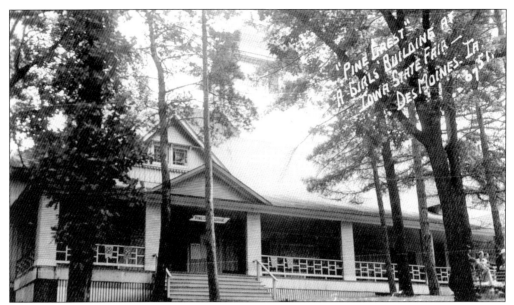

Pine Crest was the 4-H Girls Dormitory until the new one (below) was built. It was located east of where the Cultural Center is today. Originally, the 4-H exhibits were in the Exposition Building, which was demolished in 1950. In 1949, the exhibits moved to the Education Building under the Grandstand. In 1965, the Poultry Building was renamed the 4-H Building, and exhibits were moved there.

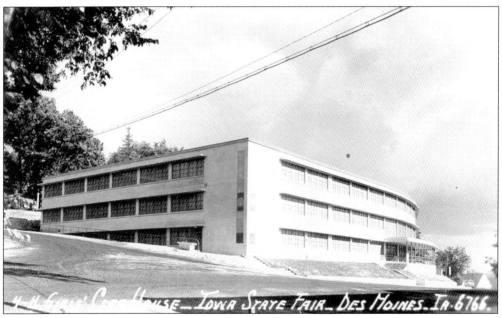

The 4-H Girls Dormitory was constructed in 1949. The girls moved in for the first time in 1950, and stayed until 1981, when they moved down the street to the Youth Inn. The old Cultural Center across the street (formerly the Women and Children's Building) was torn down in 1980, and the girls' dorm became the Cultural Center. It is now the home for fine arts, photography, and arts and crafts.

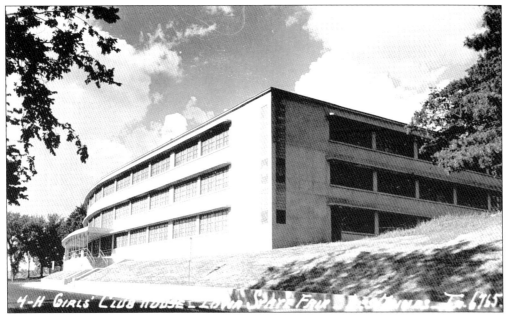

Shown on this page are two more views of the 4-H Girls Dormitory. The top card was postmarked August 28, 1950, the first year the girls moved in. The sender wrote, "It hardly seems possible. I'm really at the State Fair, but now that we're all set in our new building, one realizes it's happened. In spite of the rain yesterday, lots of people were here. Tomorrow at 10:45 is the big demonstration. Hope we turn out okay. I met the girls from Dyersville yesterday. They are demonstrating this morning. Their bed is in the next row over from mine. We're meeting lots of nice kids and having quite a time. See you soon." It was signed Mildred.

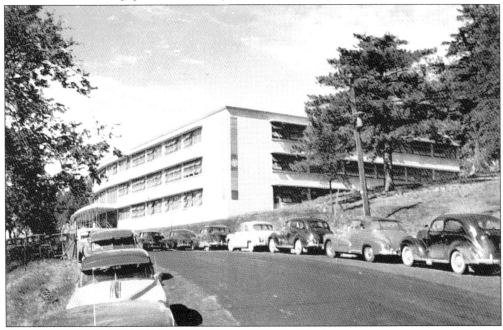

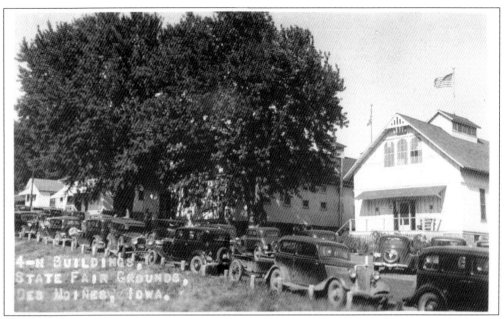

This 1930s photograph looking north shows the old 4-H Dining Hall and other 4-H buildings. The Dining Hall opened around 1923. During the 1930s, it was a custom to hold evening candle-lighting ceremonies on the hillside near the Pine Crest and Hill Crest Lodges. The 4-H members would light one candle for each Iowa County to "carry home the inspiration of the 4-H State Fair Camp."

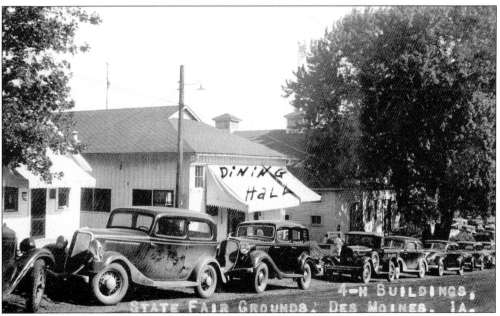

Another 1930s photograph looking south shows several of the old 4-H buildings. The buildings, from left to right, were the 4-H Club Office, Dining Hall, and the 4-H Camp Canteen. At various times they were also used as boys' dormitories. These buildings were all torn down some time during the 1950s.

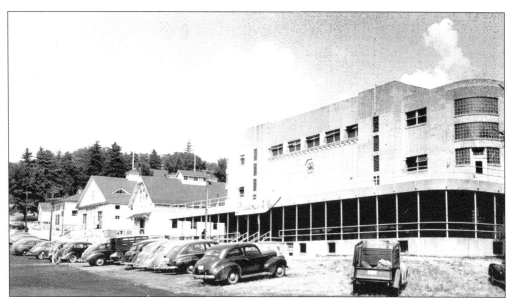

The large concrete building in this late 1940s photograph is the 4-H Dining Hall and Dormitory. Construction was started as a WPA project in 1939. In 1941, even though the building was not completed, the dining hall opened. During the war years (1942–1945) it was used by the Army Air Force for storage. It was used as a dormitory for the first time in 1946. Older dormitories next door took care of overflow.

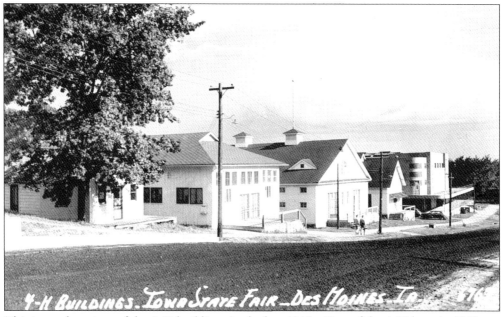

This is another view of the 4-H buildings in the late 1940s. One of the 4-H boys in 1947 was Don Greiman from Garner, whose heifer Elba Maid won the Angus Grand Championship. Greiman went on to be elected to the Iowa State Fair Board in 1966, and remains a member to this day. He served as president of the Iowa State Fair Board from 1977 to 1980, and again in 2000 and 2001.

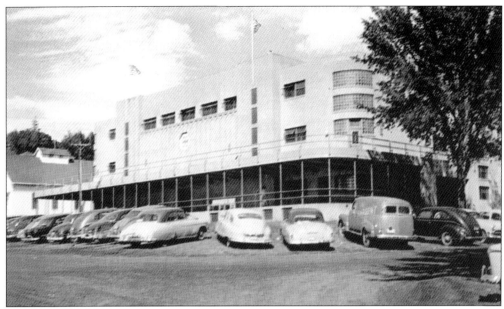

Shown here are exterior and interior views of the 4-H Dining Hall and Dormitory, now called the Youth Inn. The dining room, which doubles as an auditorium, has a seating capacity of 1,200. In 1946, Mrs. A. W. Neff of Albion, who had been the dining hall director since 1930, revealed her grocery list. For one meal she would order 250 pounds of ground meat for meatloaf or 450 pounds of fresh ham, 300 pounds of fish on Friday, and 450 pounds of chicken for Sunday dinner. Breakfast was 250 pounds of bacon and five cases of eggs. It was operated non-profit, with the boys getting meals as low as 45¢. The dormitory on the second floor provided sleeping quarters for 600 boys. In 1981, structural changes were made to the building, and it became two dormitories; one for boys and one for girls.

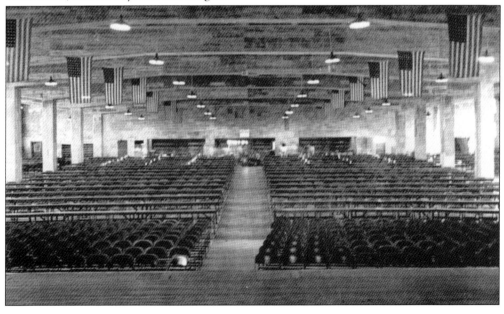

Five

THE 1909 U.S. ARMY TOURNAMENT

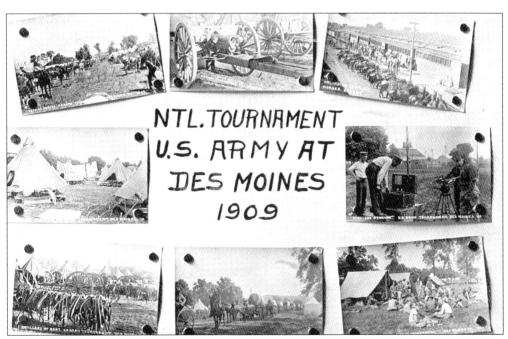

The national U.S. Army Tournament was held in front of the new steel grandstand at the fairgrounds September 20 through September 25, 1909, after the Iowa State Fair was over. Commanded by Brig. Gen. Charles Morton, it was advertised as "the largest peace time gathering of troops of the Regular Army in the history of this country!" Admission was 50¢, reserved seats 75¢. On the first day, 20,000 people attended, and an estimated 100,000 attended over the six-day tournament. A total of 5,200 soldiers from every branch of the army participated for $6,000 in prize money. Events included wall scaling, roman race, infantry drill, artillery drill, bareback squad, bridge building and demolition, and musical sabre drill. The tournament raised $20,000 for the Army.

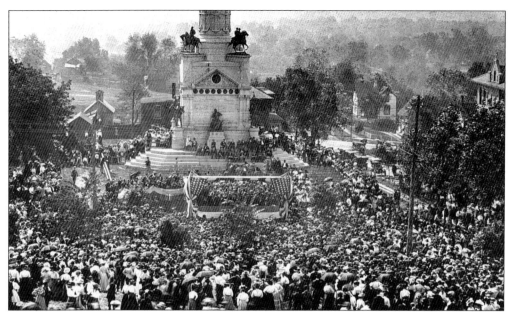

On Monday, September 20, 1909, the army tournament was inaugurated with a huge parade of troops and equipment in downtown Des Moines. They passed by the Soldiers' and Sailors' Monument on the capitol grounds in front of a reviewing stand filled with many dignitaries, including Pres. William Howard Taft. A crowd of 75,000 turned out at the monument, where the president made a speech after the parade passed by.

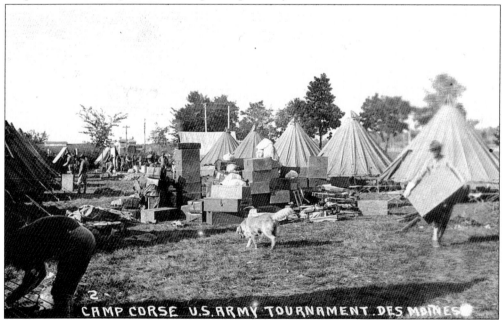

During the tournament, soldiers camped south of the fairgrounds between Dean Avenue on the north and the railroad tracks on the south and between East Thirtieth Street on the west and East Thirty-fourth Street on the east. It was named Camp Corse after Civil War Gen. John Corse from Burlington. Some soldiers were camped inside the fairgrounds south of the Grand Avenue entrance, and the quartermaster and commissary were near the Livestock Pavilion.

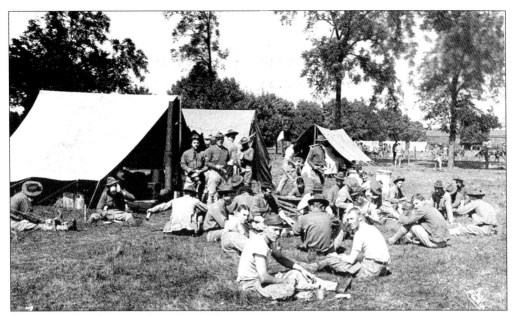

Seventy soldiers from the Fort Des Moines engineering corps prepared the tournament camp, which covered about 135 acres. The camp had 8,732 feet of water mains with 120 water taps, 60 shower baths, and "sinks" for "refuse" lined with quick lime. Engineers installed a telephone system throughout the grounds so officers could communicate with each other. A wireless telegraph system was also installed.

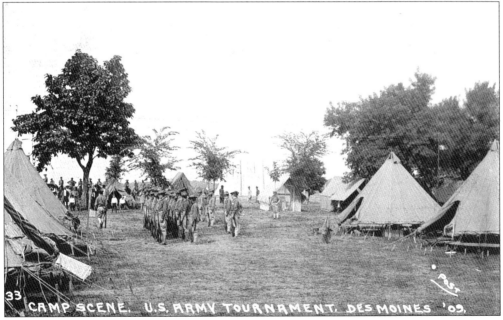

The engineers laid out camp streets 50 feet wide. Instead of old-fashioned A-frame tents, most soldiers had the new Sibley Tents, accommodating six soldiers with individual cots. Circular in shape and resembling teepees, they were 16 feet in diameter. Only one pole in the center was required for support, with ropes holding out the walls. An opening at the top would draft smoke if a camp stove or fire was used.

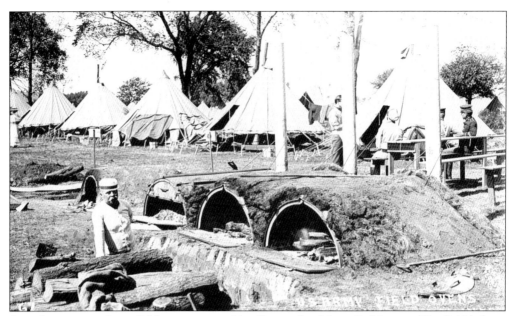

A cook poses near large field ovens covered by dirt, each with a tall chimney. The field bakery and commissary were across the street from the Livestock Pavilion. Each camp had its own mess tent, but the field bakery provided its goods to all the soldiers. To get the public into closer touch with what the army was doing, the camp was opened to civilians to "poke around and ask questions."

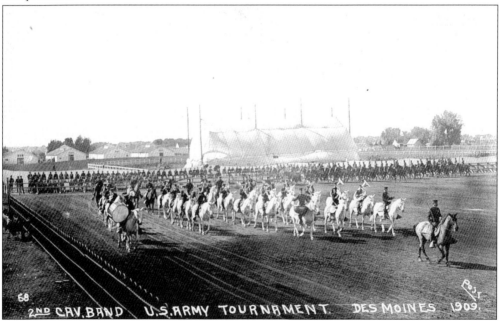

The Grand Review of troops started promptly at 2:00 each afternoon. On the first day of the tournament, Colonel Loughborough rode in front followed by the 2nd Cavalry Band. Then came the troops in the following order: 13th Infantry, 16th Infantry, Signal Corps, 4th Artillery, 5th Artillery, 2nd Cavalry with platoon of machine guns, 4th Cavalry, 15th Cavalry, and the 7th Cavalry. The large tent in the background housed the dirigible.

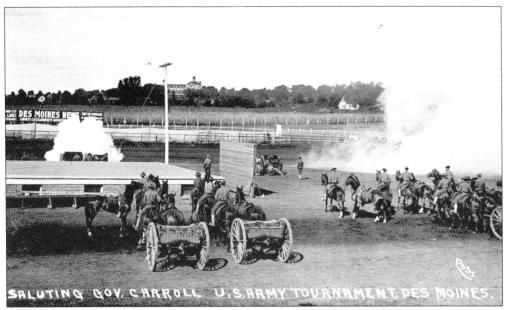

On September 24, Iowa governor B. F. Carroll was the guest of tournament commander Brig. Gen. Charles Morton. He was saluted by the firing of 17 guns. Carroll, along with Congressman J. A. T. Hull (who had been instrumental in bringing the tournament to the fairgrounds) and state treasurer W. W. Morrow, sat with General Morton in his box to watch the tournament.

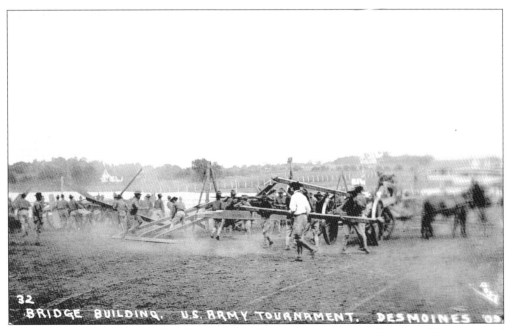

Lt. Douglas MacArthur (in white shirt) oversees his troops setting a world record of 3 minutes and 43 seconds to erect a spar bridge, pass over it while under attack, and demolish it. In 1908, when MacArthur became commander of Company K, 3rd Battalion Engineers, at Fort Leavenworth, Kansas, it was rated lowest of 21 companies. Under his command, Company K was rated the first. MacArthur later became a World War II supreme allied commander, and a five-star general.

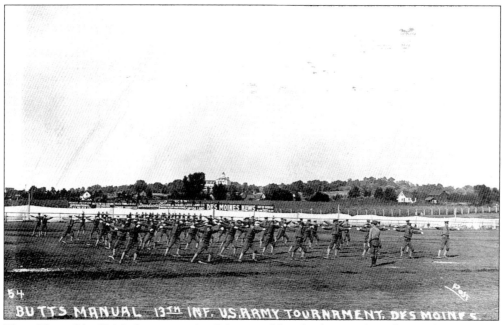

The soldiers of the 13th Infantry, wearing fatigues and "resplendent in white gloves," demonstrated the Butts Manual, a drill where soldiers with rifles do calisthenics in unison to music. There were no vocal commands during the drill; instead the men took their commands from drums and bugles of the regimental band. A reporter wrote "the troops moved as a single man and the drill was faultless."

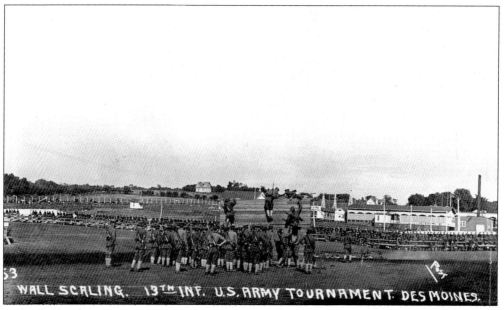

In the wall scaling contest, squads of eight men dash 25 yards to a wall 16 feet high, scramble over it, then run 15 yards and fire five shots from a recumbent position. The 3rd Battalion of the 16th Infantry won the event with a time of 27 seconds. Second place went to the 2nd Battalion of the same regiment, and third went to the 2nd Battalion of the 13th Infantry.

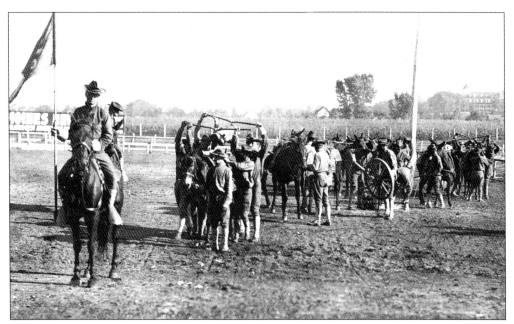

In the machine gun contest, crews of six men, with a mule carrying their gun, dash 100 yards, unload and assemble the gun, fire a round, disassemble it and get back to the starting point. Troopers are shown here lifting the heavy gun off the mule's back. On September 21, the 16th Infantry, with the help of Pete, their mule, won the event in record time.

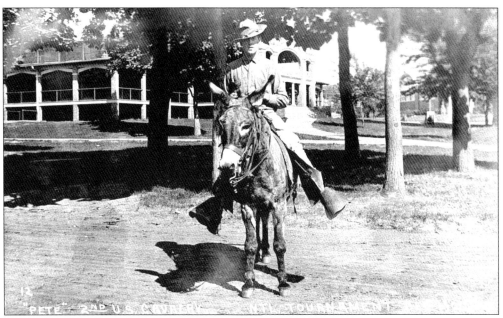

Pete, who had been an army mule for about seven years, became famous at the tournament. He helped the 16th Infantry win the machine gun contest in a record time of 51.25 seconds, breaking a record that had stood for five years. The next day, Pete, known as "the mule that won't run unless someone has hold of his tail" was decorated in red, white, and blue, and paraded around the racetrack.

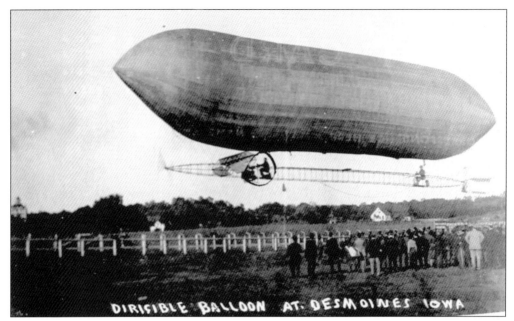

The Thomas Baldwin Dirigible Balloon, powered by a Curtiss engine, had the distinction of being the first powered aircraft to be purchased by the U.S. Military. Acquired by the Army in 1908, it was designated Signal Corps Dirigible No. 1, or simply SC-1. It made several flights during the tournament, piloted by Lt. Frank Lahm. "Hats were thrown in the air and men danced about like excited school boys," when it appeared over the fairgrounds.

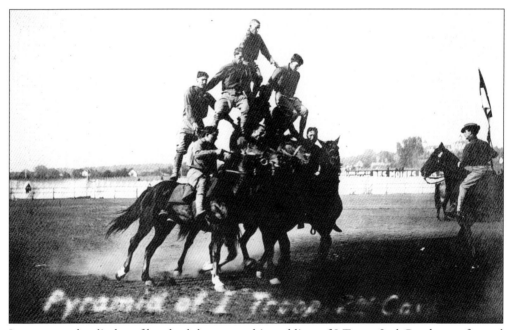

In a spectacular display of bareback horsemanship, soldiers of I Troop 2nd Cavalry performed several demonstrations, including a 10-man pyramid on the backs of four horses. The amazing thing about this demonstration was the fact that it did not stand stationary. The men raced around the arena, jumped over hurdles, and exited the arena while still in the pyramid.

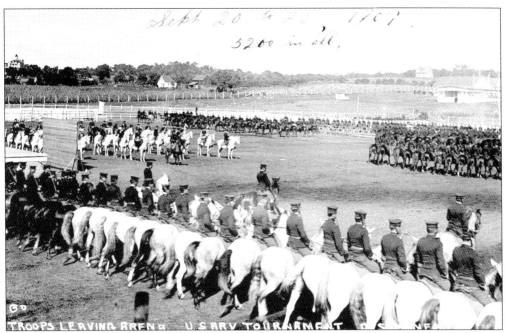

One of the crowd favorites at the tournament was a demonstration by Captain King of the 2nd Cavalry and his "gray horse troop." King's men performed several intricate drills in front of the Grandstand. To climax their demonstration, the men commanded their horses to lie down, then got down on the ground themselves and fired their rifles over the bodies of their prostrate horses.

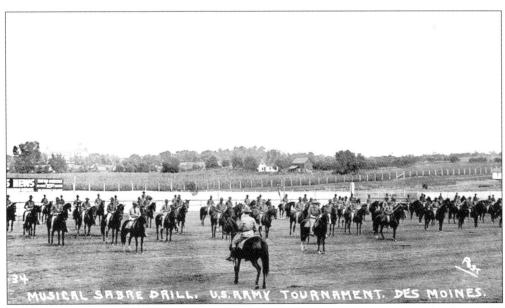

Three hundred mounted soldiers from the 2nd Cavalry demonstrated a "Musical Sabre Drill" at the tournament. Spread out over the entire field, they performed a series of choreographed moves timed to music from the military band. The horsemen, performing their intricate moves in unison, provided a striking sight with their "steel blades flashing in the sunlight." The horses were trained to respond to leg commands as well as the rein.

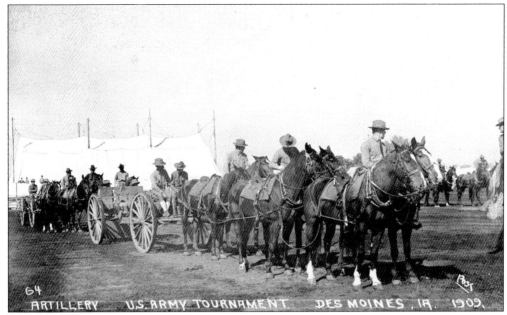

Another tournament event was a drill performed by the 6th Field Artillery. There were four, three-inch cannons, each trailing a caisson (four-wheel wagon) pulled by six horses. Starting at one end of the arena, they would race four abreast towards the other end, wheel around at the last second, and race back to the starting point. Then the caissons were unlimbered, the cannons pointed towards the crowd, and all four cannons fired in unison.

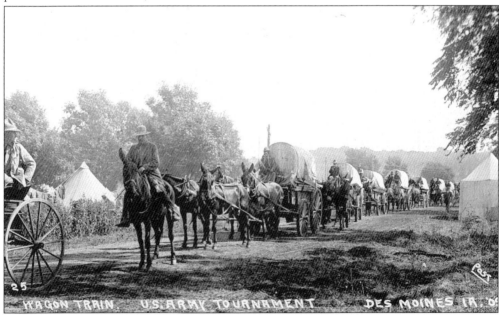

After the tournament, the 2nd, 4th, 7th, and 15th Cavalry, and Battery E of the 6th Field Artillery, marched to Omaha for the Ak-Sar-Ben Tournament. Company D of the Signal Corps, the 16th Infantry, and the field bakery left by train for Omaha. Company K of the 3rd Engineers left by train for Fort Leavenworth; Battery C of the 4th Field Artillery left for Fort Russell, Wyoming; and the hospital corps left for Fort Riley.